Journeys Around Whitby

Whitby

Noel Stokoe

AMBERLEY

First published 2015

Amberley Publishing
The Hill, Stroud, Gloucestershire, GL5 4EP
www.amberley-books.com

Copyright © Noel Stokoe, 2015

The right of Noel Stokoe to be identified as the
Author of this work has been asserted in accordance
with the Copyrights, Designs and Patents Act 1988.

ISBN 978 1 4456 4637 4 (print)
ISBN 978 1 4456 4638 1 (ebook)

British Library Cataloguing in Publication Data.
A catalogue record for this book is available from
the British Library.

Typesetting by Amberley Publishing.
Printed in Great Britain.

Contents

Introduction

My wife and I came to live in Whitby in August 1980 and we have greatly enjoyed living and raising our family here, as we think it to be one of the prettiest areas in the country. After living here for a considerable time I thought that I knew the area very well, but my job as the Whitby Mobile Library driver took me to many local villages 'off the beaten track' which were a real treat for me to discover. I hope that this book, in some small way, will invite visitors to the area to be a little more adventurous and to explore further what the Whitby area has to offer.

Whitby itself is a picturesque fishing port famous in particular for its contributions to the whaling industry but also for its notable denizens, among them being the navigator and cartographer, Captain Cook; the fictitious Count Dracula, the eighteenth-century explorer Captain Scoresby; kippers and much more! It is surrounded by the North Yorkshire Moors National Park and its majestic and rugged beauty serves as a natural haven for wildlife and is ideal for ramblers. In the summer when the heather blossoms it is a spectacular sea of purple. For anybody interested in steam railways there is the North Yorkshire Moors Railway which, at twenty-one miles, is the longest preserved railway in the country, which tracks through spectacular scenery as it carves its way through the National Park between Grosmont and Pickering. For those interested in architectural history, there is the famous Whitby Abbey, as well as various ruins of the alum industry, ironstone working and brick manufacture in the Whitby hinterland.

The old twenty-two mile railway line between Whitby and Scarborough was removed in the 1960s, but the track is now a bridleway for the whole distance. Cycles can be hired along the route which is now popular with hikers, cyclists and horse riders alike. There is also the stunning North East coast taking in beautiful villages such as Staithes, Robin Hood's Bay and Ravenscar. There is just so much to see in this relatively small area.

Each of the journeys gives a detailed description of the route to be taken, quoting road numbers where applicable (many of the smaller roads are not numbered). Each chapter also features a map of the described journey, along with photographs of places of interest along the route. At the end each route description, there are notes on all the villages travelled to, to help list as many points of interest as possible.

The routes included here are just suggestions of where to go for days out from Whitby, although it would also be very straightforward to produce your own routes if specific locations appealed to you. Happy exploring!

Journey 1

A Journey to Heartbeat Country and the North Yorkshire Moors Railway

The first route that I shall write about takes in the village of Goathland – instantly recognisable as the on-screen location of Aidensfield in the popular ITV series, *Heartbeat*. The series has certainly put the area on the tourist map with dozens of coaches going through the village every day as part of their '*Heartbeat* tours'.

To begin this journey, when leaving Whitby take the A171 out of town and at the 'Four Lane Ends' roundabout take the first exit onto the B1416 to Ruswarp. Continue down Ruswarp Bank through the village and take a right turn onto the B1410, signposted Briggswath and Sleights. Drive through Ruswarp, past the water mill and weir on the left and on through Briggswath and, at the junction with the A169 turn left into Sleights, continue straight through the village passing the church and garage on the left and up Blue Bank – a notorious hill with a 20 per cent incline – which leads to the North York Moors, drive for a couple of miles and then take the second right-hand turn that is signposted for Goathland. Carry on in this direction for a short distance and then take the right-hand turn signposted for Beck Hole; at this point, the road meanders down for over a mile and a half before reaching the village of Beck Hole. Then continue over the narrow stone bridge, past the Birch Hall public house and then up the steep hill that leads out of the village and on into Goathland.

Just before entering Goathland, there is a turning on the left that signposts Darnholme as being half a mile away, this has a ford with stepping stones and is very picturesque, it is only a very short detour to make should you want to visit it before entering Goathland.

There is a large car park with public toilets just before the 'T' junction should you wish to stay and look round the village. If not, turn left at the junction and continue down to the railway station – which also has car parking – or right, making your way through the village past the shops and garage and continue on down to the church on the left and the famous Mallyan Spout Hotel on the right. At the mini-roundabout, take the first exit – this road leads back to the A169 with views of the early warning system at RAF Fylingdales. At the 'T' junction turn right towards Pickering and travel another four miles past the Saltersgate Inn and the Hole of Horcum on the right. Continue on this road for another two miles before turning right onto the road signposted for Lockton & Levisham past the cricket ground on the left. Lockton is reached in less than half a mile with Levisham a mile further on; this is a difficult drive down a steep ravine

before a steep climb up the other side. The village is well worth the effort with some lovely houses and cottages set back away from the road with a wide green running for the whole length of the village. Levisham Station – which is on the North Yorkshire Moors Railway – is a further two miles further on, through some spectacular scenery. There is only one way in and out of these villages, so a return along the same road is required. Once back onto the A169 it is a straight drive back towards Whitby, through Sleights and then up the hill beyond to pick up the roundabout on the A171, turning right and back another two miles into Whitby.

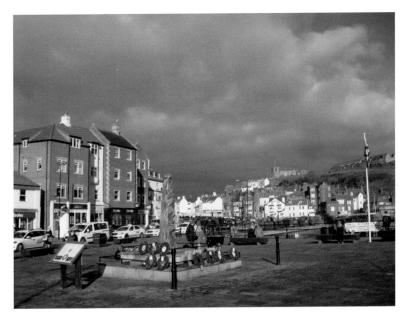

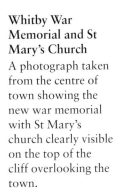

Whitby War Memorial and St Mary's Church
A photograph taken from the centre of town showing the new war memorial with St Mary's church clearly visible on the top of the cliff overlooking the town.

WHITBY

As all five routes start and finish in Whitby, it seems appropriate to describe the town first, as it is now one of the most popular tourist destinations in Yorkshire. It is such a picturesque town and has retained much its original character despite new housing and retail developments that have been built over the last decade. Almost without exception any calendar of Yorkshire will feature a view of Whitby.

The town has a population of approximately 14,000 and is split in two by the River Esk, the old part of town – with its narrow streets, alleys, ginnels and yards – being on the East Cliff, and the more recent West Cliff being mostly Georgian and Victorian, with hotels, such as the Royal – which was made famous by Bram Stoker, who is said to have written *Dracula* while staying there. Historically, Whitby was known for being a fishing and whaling town and was also the home of Captain James Cook, who left Whitby to discover Australia, New Zealand and the Pacific. The building he lived in, located in Grape Lane, now the Captain Cook Museum, which is excellent, and well worth a visit.

In the mid-1500s the town was a small fishing community with no more than twenty houses, but this was soon to change. At the end of the century alum deposits were discovered at Sandsend, three miles from Whitby; alum was used for medicinal purposes, but also in curing leather and for fixing dyed cloths. Workmen were brought into the area secretly in an effort to set up the process in Britain as Spain had previously maintained monopolies on its production and sale. Once the industry was established, imports from Spain were banned and England became self-sufficient. Whitby grew significantly through trade as a port town as a result of the alum industry as it was also necessary to import coal from the Durham coalfields to process it.

Shipbuilding grew in the town as there was a ready supply of local oak, and by

The West Side of Whitby
This photograph shows two
fishing vessels in the centre, and
behind them is the fish quay
where the catches are processed.
Some Victorian hotels can be seen
at the top of the cliff; these were
built after the 'Railway King'
George Hudson brought the
railways to Whitby.

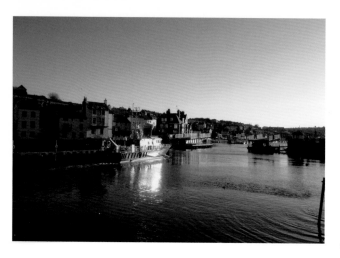

East Side of Whitby
Looking from the west side of
Whitby down to the swing bridge
that has been opened to allow
a Fisheries Protection vessel
through towards the marina. ©
Jane Stokoe

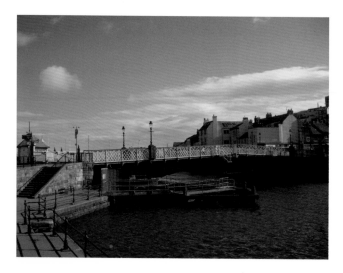

The Swing Bridge
The steps leading down to the
harbourside are usually busy with
children fishing.

100th Anniversary Celebrations
The swing bridge celebrated its 100th birthday on 7–8 August 2009; there were celebrations and I could not resist taking my 1953 Jowett Bradford van along to commemorate the occasion! Image © Ben Stokoe

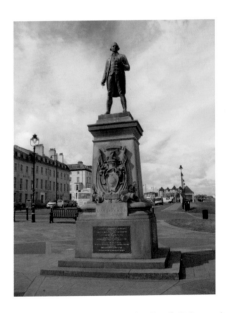

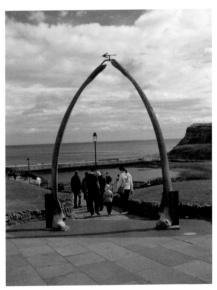

Above left: **The Captain Cook Memorial**
The memorial stands proudly on the West Cliff from which he left Whitby for his three voyages of discovery to Australia, New Zealand and the Pacific.

Above right: **The Whale Bone Arch**
Many people believe that the arch is made from whale jaw bones but they are, in fact, ribs.

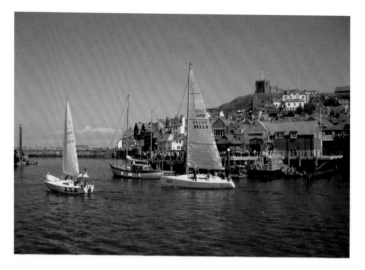

St Mary's Church and Whitby Abbey
Both churches are reached by climbing up the famous 199 Steps to the top of the cliff clearly visible to the very right of the picture.

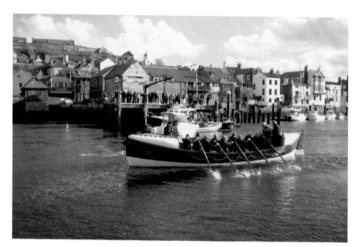

The Old Whitby Lifeboat
This has recently been restored; it is seen here being rowed past the Lifeboat Station to mark the centenary of the loss of the SS *Rohilla* which ran aground off Whitby at Saltwick Nab.

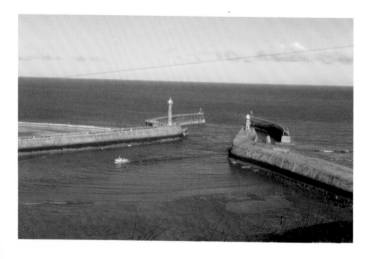

Whitby Harbour Entrance
The harbour entrance, as seen from the east side at the top of the 199 Steps. © Jane Stokoe

1791 it was the third largest shipbuilding town in England, with only London and Newcastle producing more tonnage. Whitby also became an important town for the whaling industry; with the first whaler leaving Whitby in 1754, by 1795 it had become a major whaling port. Whale blubber was boiled to make oil to use in lamps and the bones used in the corsetry trade, but demand fell as ladies' fashions changed. The most successful year for the town was 1814, but after that the industry fell into decline, and by 1831 only one whaling ship remained in the town.

During Georgian times, Whitby was developed as a spa town and it was during this period that many of the large hotels on the West Cliff were built to cater for the influx of visitors coming to the town. Tourism also increased after the railway arrived in Whitby in 1839.

Another industry to develop during the Victorian era was that of gemstones, in particular, Whitby Jet. Unlike other precious stones, his stone is derived from the compressed fossilised remains of monkey puzzle trees and is found in the cliffs at Whitby and the surrounding moors. It had been used to make beads and jewellery since the Bronze Age, but it became incredibly popular after Queen Victoria was seen wearing such jewellery while she was mourning the death of her husband Prince Albert.

There are so many attractions to look out for in Whitby. On the east side there is the Abbey and St Mary's church at the top of the 199 Steps, the Captain Cook Museum in and the Kipper Factory. On the west side there is the Royal Hotel; the Whale Bone Arch; the Captain Cook Memorial; the Swing Bridge, which celebrated its centenary in August 2009; Pannet Park, which has the Whitby Museum in its grounds; the harbour and piers; bandstand and Victorian railway station to name just a few. There are also a large number of cafes, public houses, restaurants, hotels and bed and breakfasts to cater for every taste.

SS *Rohilla* Remembrance Service

My son and I were lucky enough to go out to sea on the RNLI Lifeboat as part of a remembrance service at the site of the loss of the SS *Rohilla* This picture was taken as we came back into Whitby harbour after the ceremony.

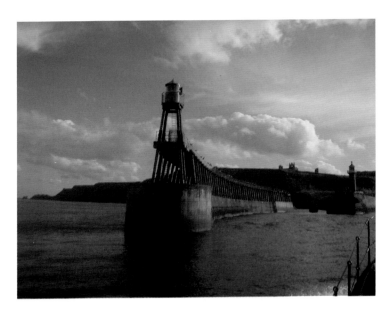

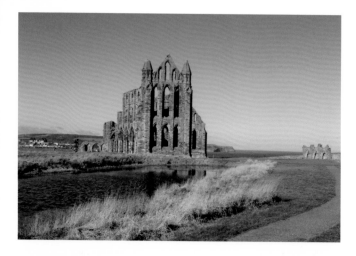

Whitby Abbey
The Abbey with the lake in front of it. © Jane Stokoe

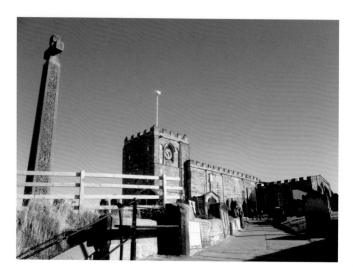

St Mary's Church
Taken part way up the 199 Steps, this photograph shows Caedmon's Cross to the left of the picture. Unveiled on 21 September 1898 by the Post Laureate Alfred Austin, the cross commemorates Caedmon the father of sacred poetry. © Jane Stokoe

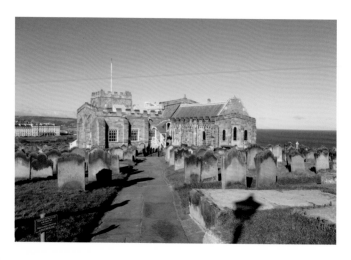

St Mary's Church, rear
St Mary's church dates from the early twelfth century and is one of Whitby's most iconic buildings. © Jane Stokoe

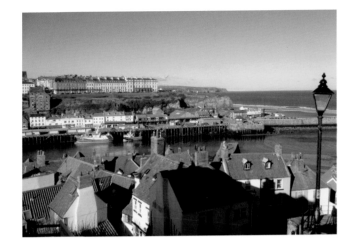

Whitby Vista
A view from the top of the 199 Steps looking across to the West Side with the Royal Hotel on the cliff top. © Jane Stokoe

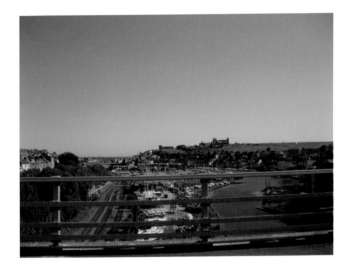

View From Whitby High Bridge
The high bridge on the outskirts of Whitby was built in 1980 this is the fantastic panoramic view of Whitby that can be seen from it.

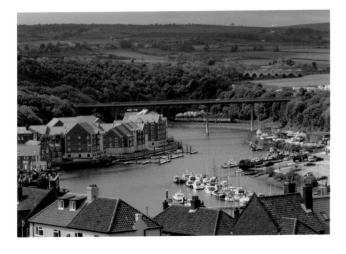

The Whitby High Bridge
This was built to allow through traffic between Middlesbrough and Scarborough to by-pass going over the old swing bridge. The railway line from Whitby to Middlesbrough passes under it, and the old Larpool brick-built viaduct for the old Whitby to Scarborough line can be seen in the distance.

RUSWARP

The village of Ruswarp is dominated by the weir and red-brick water mill built in 1752, it was burned out in 1911, so was rebuilt to its present design and continued to operate as a working mill until 1989. By this point, the mill was almost derelict, but it has since been restored – in keeping with its original character – and converted into homes and flats having been extended somewhat.

Ruswarp is also home to a weekly livestock market (every Wednesday from 11 a.m.). This market, which is full of local character, and strongly recommended to those with an interest in the local agricultural life, has been in existence since 1900. Originally the farmers would lead their livestock over the fields and along the road, or use special rail trucks, as the railway station was just round the corner from the market. It has been owned since 1930 by the local auctioneers, Richardson & Smith, with all livestock being transported nowadays by road. The nearby railway station is still in use and is part of the Northern Rail Esk Valley line which runs through the valley to Middlesbrough.

Steam trains are now also a common sight with steam specials running to Grosmont and linking up with the North Yorkshire Moors Railway from which point they continue right through to Pickering, or direct to Middlesbrough. Close to the station is the Bridge Inn, a typical nineteenth-century country public house, the Chainbridge Tea Rooms and a miniature train track. Rowing boats can be hired a little further down the river from here and have been available from this location since at least the 1930s. It is very relaxing to enjoy the River Esk and surrounding countryside from the tranquillity of water.

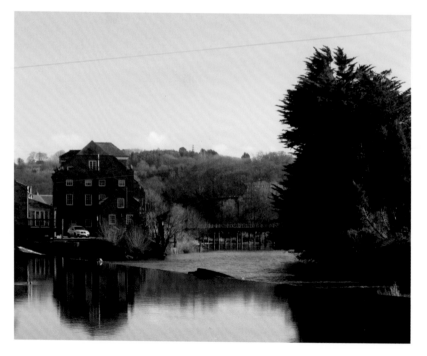

Ruswarp Mill
The Mill has been on this site since 1752 but has been in its present form since 1911 and operated until 1989. It has since been extended and converted to flats and houses.

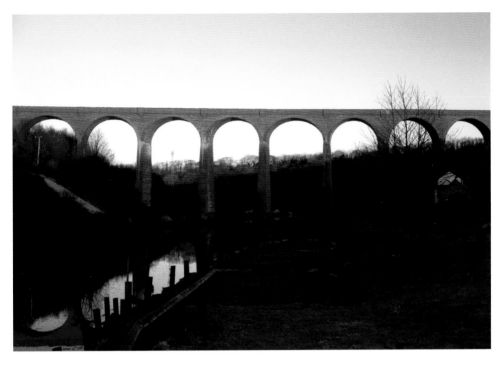

The Larpool Viaduct
Leaving Whitby towards Scarborough there is the magnificent 125-foot high Larpool Viaduct.

Bridge Over the River Esk
This photograph shows the railway station just visible at the other side of the bridge, and the Bridge Inn and the Chainbridge Tea Rooms are also close by.

Ruswarp Rowing Boats
Rowing boats have been available to hire just outside Ruswarp since the 1930s.

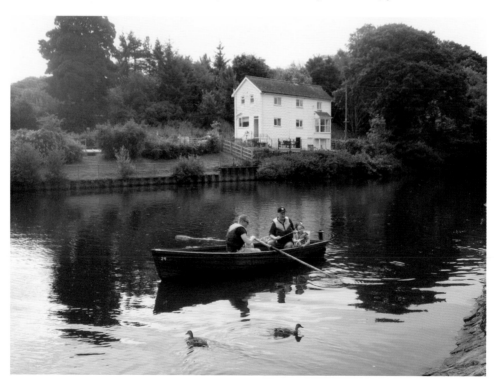

Relaxing on the Esk
A family relaxing on a rowing boat from Ruswarp. © Jane Stokoe

BRIGGSWATH

The village is probably best known for its garden centre, Perry's Plants, a garden supplier renowned for its unusual plants and tea rooms which have been there since the 1930s. The centre overlooks the River Esk and has stunning views of the surrounding areas. Just past these on the right is the Wesleyan Chapel, there has been a Methodist presence on this site since 1820, but this present building was built in 1905. The Manse is attached to the chapel but this was in existence before the new chapel was built.

BECK HOLE

Is a very small hamlet which is made up of a handful of cottages and a pub called Birch Hall, the village green has quoits pitches. Quoits is thought to have been a game played by the Romans in Britain 2000 years ago, but the game has certainly been played in Beck Hole for over 1000 years. The Association of Amateur Quoits Clubs for the North of England was the name given to the official body that laid down the 15 rules that were published in *The Field* in 1881. This set of rules constituted what is now called The Northern Game and it has remained largely unchanged ever since. The rules of the game dictate that the hobs (stakes that the quoits were aimed at) be spaced 11 yards apart in 3-foot squares of clay. The quoits (hoops) measure about 5 ½ inches in diameter and weigh about 5 ½ pounds.

The 1851 census records only six dwellings in Beck Hole, but this was to change very quickly as, by 1857, the Industrial Revolution was in full swing and mining for ironstone was developing as a major industry in the area with two blast furnaces beside the river producing pig iron that would be transported to Whitby for trade. This increased activity brought with it a rapid increase in workforce, and of course, their families. A row of thirty-three workmen's cottages were built in the part of Beck Hole known as Buber Wood and by the early 1860s over 200 men were employed. This boom was short-lived as, by 1867, the mines had closed and the furnaces dismantled. By 1871, only Birch Hall (the cottage opposite), White House and just thirteen others of the new cottages were occupied.

Soon after this, the whole row of cottages were emptied and were later demolished – the stone being taken away to build Malton Railway Station. Today, all that remains of these cottages are a few of the stone gateposts along the side of the path. Beck Hole slowly became a quiet backwater hamlet again, and little has changed since.

In 1873, the present stone bridge was built, replacing the old wooden one. Electricity would later come to Beck Hole in 1948, running water in 1952. Until 1989 there was no television reception, so residents clubbed together to raise the money required to erect their own mast at the top of the hill, which brought the signal down into the valley. This was used until 2002 by which time satellite transmission was available.

Birch Hall Inn can trace its history back to around the early 1600s, but it was in the 1850s, at the time of the influx of ironstone and coal workers, that it was developed from two adjoining cottages to include a provisions store with accommodation above

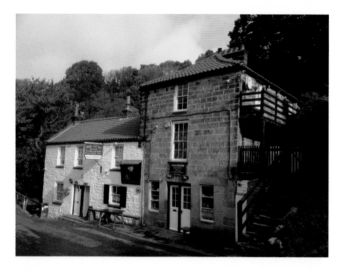

Birch Hall

Birch Hall has been a public house since the 1600s. During the 1860s, 200 men worked here mining ironstone until steel production took over from iron.

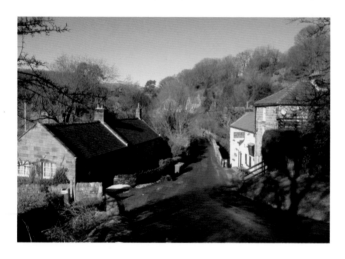

Birch Hall as seen from Goathland. © Jane Stokoe

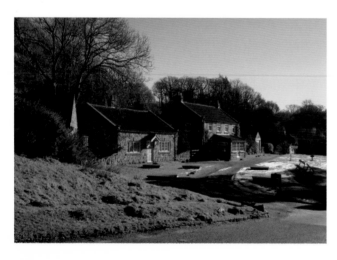

Beck Hole Village Green

The green in Beck Hole with the quoits pitches clearly visible. © Jane Stokoe

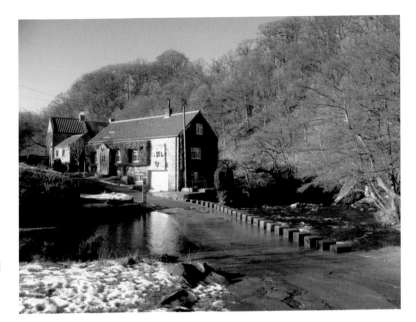

Darnholme

After leaving Beck Hole for Goathland a mile away a very short detour can be made to Darnholme which is a very small hamlet of a handful of houses. © Jane Stokoe

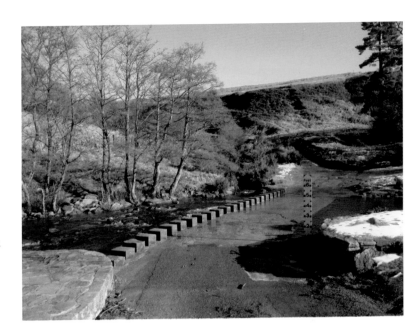

Darnholme Stream

Another view of Darnholme from the other side of the stream. © Jane Stokoe

for a resident cobbler on the top floor. These alterations were carried out by Ralph Dowson, who was the Inn's landlord at the time. He was also employed as a wagoner at the nearby Aislaby quarry. It is said that each evening he came home with a huge flagstone in the back of his cart and used his heifers to drag it into place on oaken beams that would later become the floor of the bar and shop – he must have done a good job, as they are still there today!

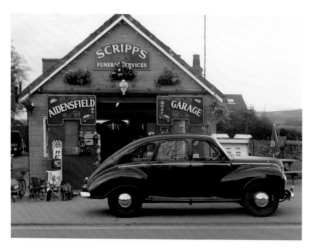

Scripp's Garage and Funeral Directors
A popular location from the *Heartbeat* series, this was in fact a working garage prior to the filming but is now a souvenir shop and museum. (Alf Heseltine)

GOATHLAND

As mentioned previously, Goathland once served as the filming location for the fictional Aidensfield, the setting of the long-running ITV series *Heartbeat* which ran from October 1992 to December 2009 – a total of 365 episodes in all! Many of the locations used in the filming are in Goathland and the surrounding area. Aidensfield Railway Station, Stores & Post Office, Scripps Garage & Funeral Directors, Aidensfield Arms (Goathland Hotel) and church. Another location filmed in Goathland for the earlier series was Kate Rowan's Surgery, this is a Bed & Breakfast establishment called Glendale House.

Goathland School has appeared many times over the years, in fact they benefited from a grant from Yorkshire Television to buy school uniforms! The location of Claude Jeremiah Greengrass' farm is also just outside Goathland, Brow House Farm. Interestingly, Aidensfield Police Station was filmed 60 miles away in Otley as was Aidensfield Police House – the true location of which can be found in a village called Askwith near Otley, Sleights Village Hall has also been used in some episodes.

The Heartbeat series are based on the *Constable* books written by the local author Nicholas Rhea, which is one of six pseudonyms used by Peter Walker. He has written around 130 books in the last forty years, thirty-eight of which are *Constable* books. This amazing career is based on many of his own experiences – whether it is from being a village bobby, a Yorkshire villager, a police press officer or a father of four.

It is not only *Heartbeat* that has used Goathland Station as a backdrop. In 2002 it was transformed into Hogsmeade for the Harry Potter film franchise, based on the stories by J. K. Rowling.

Goathland was also the location for the filming of the recent BBC drama film *Testament of Youth* based on the memoirs of Vera Brittain during the First World War, it was shot in several locations within the North York Moors National Park including Goathland, Egton Moor, Fylingdales and the North Yorkshire Moors Railway.

There has been a church in Goathland for at least eight centuries and one on the site of St Mary's church since Elizabethan times. The church today was built in 1896 by

Walter Brierly of York, he said of the design:

> The qualities of simplicity, breadth and sturdiness were felt to be especially required for such a bleak moorland situation, and were aimed at in the design.

The alter has a mouse on its right hand side which confirms that it was made by Robert Thompson of Kilburn – he was known as 'The Mouseman' as all his work features a carved mouse on it.

The war memorial on the green in the village was designed by Dorothy Burrow and erected in 1922; paid for by public subscription, it is very similar in design to the Lilla Cross, which is the oldest Christian Cross on the North Yorkshire Moors, located on Fylingdales Moor. It is inscribed 'True love by death is tried, Live thou for England. We for England died'. It bears the names of the eighteen men from the parish who died

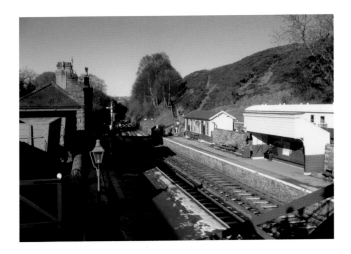

Goathland Railway Station
A photograph of Goathland railway station depicting the platform and shop. © Jane Stokoe

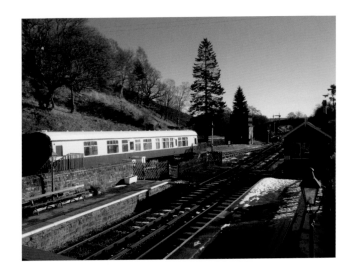

Goathland Railway Accomodation
During the summer months the railway carriage can be hired as holiday accommodation. © Jane Stokoe

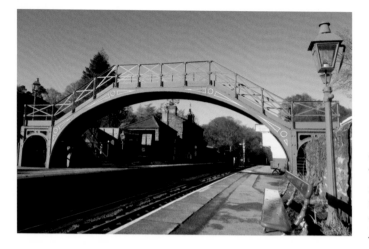

Goathland Railway Bridge

The bridge at Goathland railway station. The building, that can be seen is the ticket office and waiting room. © Jane Stokoe

Goathland Village Green

A classic photograph of the green in Goathland. © Jane Stokoe

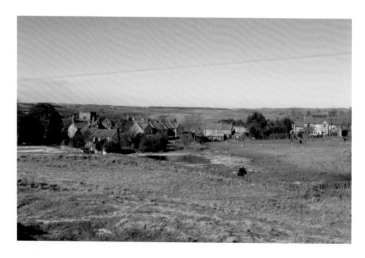

St Mary's Church, Goathland

Looking at Goathland from the south with St Mary's church to the left. © Jane Stokoe

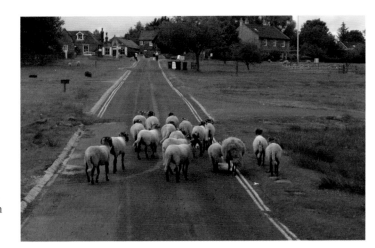

A busy day in Goathland!
This road leads up to the shops and green on the left. As in many of the villages in the area sheep are allowed to graze freely.

RAF Fylingdales
Leaving the village past St Mary's church on the left the road leads back to the A169 Whitby to Pickering when RAF Fylingdales comes into view. © Jane Stokoe

Goathland War Memorial
The village green and war memorial in Goathland. © Jane Stokoe

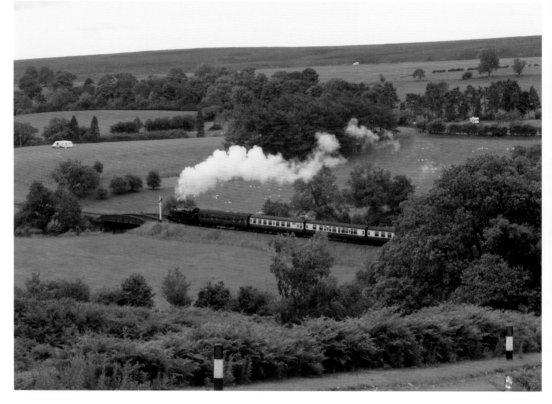

Goathland Railway Line
The romantic sight of a steam train leaving Goathland on its way to Levisham and Pickering.

in both World Wars. It is interesting, however, that the Second World War is shown as 1939–45 whereas the First World War is shown as 1914–19; it is possible that at least one poor soul died from his war wounds several months after the war ended, but before the memorial was commissioned.

The Mallyan Spout Hotel is probably the best known hotel in the village, it was originally a large country house, built in 1892, and is located opposite St Mary's church. Behind the hotel is 70-foot high Mallyan Spout waterfall, which is only a short walk away – the views from here are stunning.

SALTERSGATE INN/HOLE OF HORCUM

The Saltersgate Inn was built in 1648 and was originally known as the Wagon & Horses; it was a coaching house where stage coaches leaving Whitby would stop to change horses. A gentleman by the name of William Hopper was the landlord in the 1760's and at that time there was stabling for sixteen horses on the opposite side of the road. In these early years it also became the focus of salt smuggling; this form of

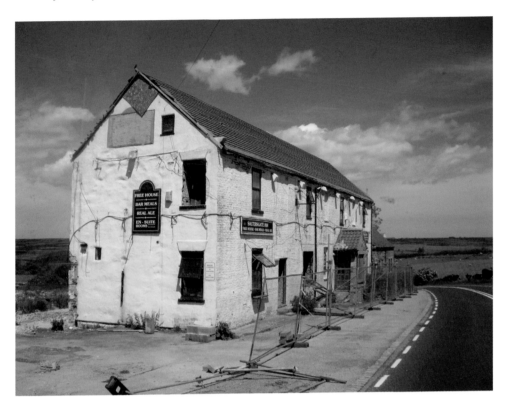

Saltersgate Inn
This rather sad looking building is the Saltersgate Inn. It closed in 2007 and originally there were plans to convert it into flat. The future is very uncertain for this historic building.

smuggling developed because salt was needed for the fishing industry of Whitby and Robin Hood's Bay, and it was heavily taxed by HM Customs and Excise.

It has been built into folk law that in the early 1800s an exciseman raided the inn one night in the hope of catching the smugglers red-handed. Sadly, he was killed in the attempt and the smugglers buried his body under the fireplace (and lit the fire) so that he would not be detected. Legend has it that the fire has never been allowed to go out since, so the exciseman's body has never been found! In reality, the fire did go out for good in 2007 (and many times before that!) when the former coaching inn was closed down. Originally there were plans to convert the building into flats and, later, a hotel, but sadly neither has happened. At the time of writing, the building is derelict, with no windows and a tarpaulin covering the roof. It has been like this for several years now, so the future looks very precarious for the building.

Behind the Saltersgate Inn is the massive Hole of Horcum which was formed by a process of 'spring-sapping' following the last ice age. Legend has it that it was created by Wade the Giant who scooped the earth up in his hand and threw it across the moor to create Blakey Topping – a large hill nearby. There is a large car park here now as this whole area is very popular with walkers and ramblers.

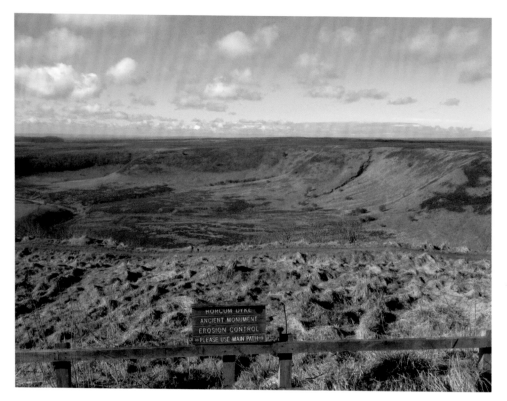

The Hole of Horcum
Legend has it that the hole was created by a giant called Wade who scooped it out with his hand and threw the earth across the moor to create nearby Blakey Topping.

LOCKTON

Lockton is a very attractive village with a population of about 150 people; it is largely unspoilt and retains much of its rural character. St Giles Church is on the main street and is a fine example of ancient church; it has a fifteenth century tower, nave and chancel;there is also a fine stained glass window depicting the Good Shepherd. The church still retains its box pews, which were particularlypopular in the early 1800s. The local pub is The Fox & Rabbit which is on the A169 Whitby to Pickering road around two miles away from the site of the church. The pub began life as an eighteenth century inn, though has now been developed to include its own restaurant and caravan park. The village did in fact have three pubs in the past, but all have closed down over the years – one of these former pubs was called The Durham Ox, the building is now a private residence, but retains its original name.

The village shop, tea rooms and art gallery have been recently re-opened following major refurbishment and are well worth a visit; the building was originally known as Stothard's Garage – the Stothards being agricultural engineers. There is also a youth hostel in the village, it occupies the old school building and has twenty-one beds.

Lockton Main Street
The main street in Lockton with the newly re-opened village tea rooms, gallery and shop to the left. © Jane Stokoe

LEVISHAM

After leaving Lockton the road drops down into a spectacular valley and makes its way past an old watermill on the right, then travels up the steep bank into Levisham village, the distance is only about a mile as the crow flies, but it is quite a challenging drive. As previously mentioned, Levisham is an elegant village set beside a long and wide village green that features on both sides of the road. At the top of the village the Horseshoe Inn – a nineteenth-century inn, which has its own restaurant and eight bedrooms for bed and breakfast – is clearly visible upon entering the village. The original parish church was the ancient St Mary the Virgin, located in the valley between Lockton and Levisham, sadly this is now a ruin. The village is now served by that of St John the Baptist, a nineteenth-century church which became the parish church of Levisham in the 1950s. Considering that it is a recently founded church there are artifacts within that date back to the times of Norman occupation, such as the font. This is a very crudely carved piece with a rough surface, originally belonging to St Mary's church, but at some time in the past it was removed and replaced with something a little more modern. The original ended up in a farmer's field as a cattle trough until it was rescued and restored. The two bells from St Mary's are also housed under the altar.

Should you wish to visit Levisham's railway station, drive past the Horseshoe Inn and continue for a couple of miles through some breathtaking countryside to reach it. Afterwards, it will be necessary to retrace your steps back to the A169 and turn left and head for Whitby.

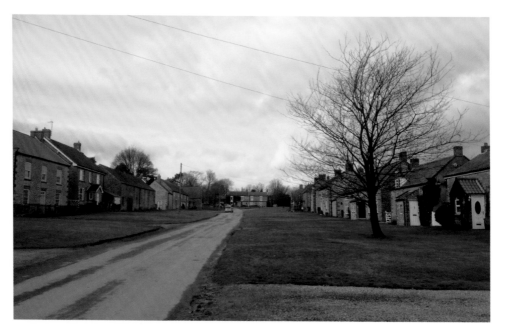

Levisham Main Street

Levisham main street with its wide greens on each side of the road with The Horseshoe Inn at the top of the village. © Jane Stokoe

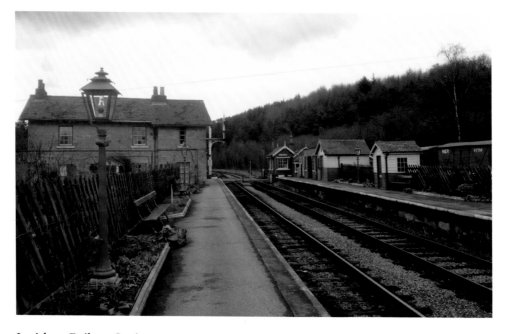

Levisham Railway Station

This is one of the stations on the North Yorkshire Moors Railway between Goathland and Pickering.

ROUNDABOUT AT THE JUNCTION WITH THE A171 & A169

As mentioned in the driving instructions at the start of this chapter, this roundabout is located through Sleights, and at the junction with the A171 Whitby to Guisborough road, this area is known as Bannial Flatts. The junction was previously a 'T junction', but was altered in recent years and replaced with a roundabout. On each side of the roundabout are stone monuments; these are not particularly impressive or noticeable, but they commemorate a particularly important event in the history of the Second World War. There is a metal inscription on the one to the left that reads,

> N. R. C. C. (North Riding County Council) The first enemy aircraft to be shot down in England during the Second World War fell 80 yards opposite this tablet on 3rd February 1940.

Upon this site, three Hurricanes of 'B' flight, 43 Squadron, shot down a Heinkel 111; the pilots were Flt Lt Townsend, Fg Off 'Tiger' Folkes and Sgt James Hallows.

Peter Townsend is perhaps best known for his romance with Princess Margaret. He had met the Princess in his role as an equerry to her father, George VI. As a result of the prevailing social doctrines of the time – when divorced people suffered severe disapproval and could not remarry in the Church of England – despite his distinguished career, he had no chance of marriage with the princess unless she renounced her royal privileges. Their relationship caused enormous controversy in 1953, and the Princess eventually gave up Townsend and married the photographer Anthony Armstrong-Jones in 1960, but divorced in 1978. Townsend was later sent to take up a post at the British Embassy in Belgium.

The Second World War Comes to Whitby

At the roundabout through Sleights where the A169 joins the A171 there are two small monuments commemorating the first enemy aircraft to be shot down in England during the Second World War.

Journey 2

To the Town That Never Was, and Tales of Smugglers

Leave Whitby going south on the A171, pass over the high bridge and, upon reaching High Hawsker, turn left onto the B1447 towards Robin Hood's Bay. At the top of the bank leading down to the village is a very old church called Old St Stephen's – it is normally open and is well worth a visit. Dropping down from this point to the top of Robin Hood's Bay, there are two large car parks (and street parking) as the steep hill down to the old village is for use by residents only. It is a strenuous climb both up and down, but is really worth the effort, nevertheless. When leaving the village continue on to Fylingthorpe, proceed straight through the village and up the steep hill that lies beyond to link up with the A171 before turning left towards Scarborough. After two miles, go past the Flask Inn on the right – which was once an old coaching inn – carry on for a further three miles and turn to the left, at the side of the Falcon Inn, and continue down to Ravenscar. It is often said that Ravenscar has a climate of its own, and is regularly covered in a sea fret that does not move very far inland. On a clear day, however, there are spectacular views from here right across the sea to Robin Hood's Bay. The Raven Hall Hotel stands at the top of the 600-foot high cliffs and overlooks the bay.

When leaving Ravenscar, the same road has to be used to get back onto the A171, but this time turn right towards Whitby. Carry on for roughly six miles before turning left onto the B1416 marked for Sneaton and Sleights, at the Red Gates corner – a very tight bend – turn left onto the road signposted for Falling Foss – this leads to a free car park. Leave the car there and walk down to the Falling Foss waterfall and Midge Hall Tea Rooms – it's just like stepping back in time!

Once back in the car, return to the B1416, on which turn left and travel for roughly one mile and take the left turn that is signposted for Sleights. Very soon after this turning there is a sign to Sleights on the right, but at this stage continue on a further winding mile to the lovely village of Littlebeck. In the centre of the village there is a ford, which, if crossed, leads back up onto the A169 Pickering–Whitby road. Part way up the Blue Bank, turn right and then follow the road back to Whitby.

Alternatively, take the same route back out of Littlebeck and this time turn left down the road marked Sleights. In the course of the next mile there is a steep descent down through the hamlets of Ugglebarnby and Iburndale, followed by a similarly steep ascent up to Sleights. This road joins the A169 at the side of Sleights church, turn right and follow the road back to Whitby.

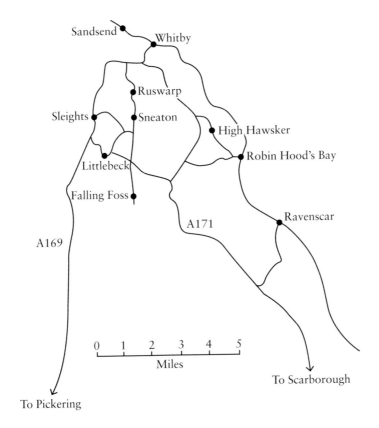

WHITBY

Though Whitby was discussed at the start of the previous journey, it seems appropriate to mention the 'Cinder Track' at this point as the route of this journey goes out via the A171 towards Scarborough. This follows the 21½ mile route of the original railway line that runs from Whitby to Scarborough, which was in use from 1885 until its closure in 1965. Once, this was a busy line, taking passengers and goods up and down the North Yorkshire coast, but it is now an off-road route through the North York Moors National Park for walkers, cyclists and horse riders. As the name suggests, the railway track was removed many years ago and the route is now a cinder track. It is a great shame that this line has been decommissioned, as it was once regarded as one of the most picturesque lines in the country. Soon after the line closed, the track was bought by the Scarborough Borough Council, ensuring that the route is still accessible to all.

When leaving Whitby along the Cinder Track, follow the path as it progresses up and over the magnificent 125-foot high Larpool Viaduct, this is a brick-built structure with thirteen spans over the River Esk. The viaduct took two years to build between 1882 and 1884. There are over five million bricks in this viaduct which cost £40,000 to build – sadly six men fell to their deaths during its construction. In 1992 British Rail sold it for £1, but the purchaser then took ownership of the cost of its repair and maintenance.

Trailways
Based in the old High Hawsker railway station is a cycle hire business which allows people to cycle along the old Whitby to Scarborough railway track.

HIGH HAWSKER

The old railway station at High Hawsker is the location of Trailways where cycles can be hired for use up and down the 'Cinder Path'. Self-catering accommodation is available in converted railway carriages that are parked on the site. The Hare & Hounds is the only pub in the village and is just a few hundred yards from Trailways along the road towards Robin Hood's Bay and they serve food there, making it very popular with hungry and thirsty walkers and cyclists! It is also popular with the guests of the large caravan park that is situated in the village.

There is a small church dedicated to All Saints which is a Grade II listed building. In 2000 a new floor was fitted and the interior updated, it now acts as a school gymnasium, drama performance area and music rehearsal room, used by the whole community.

FYLINGTHORPE

The village of Fylingthorpe is well equipped with its own school, post office, butcher, village store and public house – called the Fylingdales Inn. This pub is very popular with walkers and tourists as food is served all day in their restaurant. There are two churches in the village, both of which are dedicated to St Stephen; firstly there is St Stephen's old church, which, as mentioned previously, is on the top of the hill that descends into Robin Hood's Bay. This church was built in 1822 on the site of a much earlier Saxon church. It is built out of sandstone and has a purple slate roof. It is listed by English Heritage as a Grade I listed building and is under the care of the Churches Conservation Trust. The interior of the church is still as it was in Georgian times, with a panelled gallery on the north and west sides supported by Doric columns, and a three tiered pulpit on the south wall with box pews. Sadly it is now a redundant church, though is still open to the public.

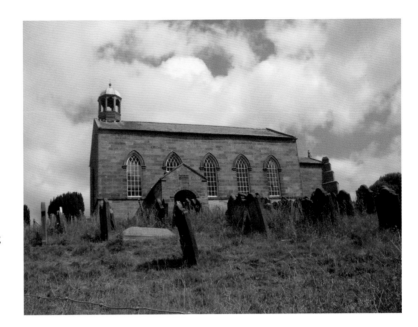

St Stephen's Old Church

At the top of the bank before driving down into Robin Hood's Bay is St Stephen's old church, built in 1822.

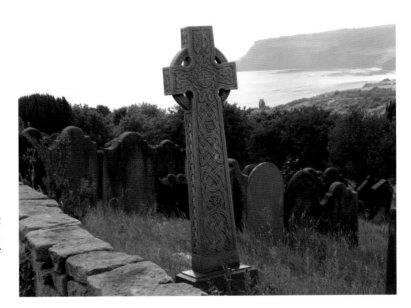

St Stephen's Cross

An ornate cross in St Stephen's old church confirming the grave yard must have one of the best views in the country!

The new St Stephen's church is much larger than its predecessor and is situated in the village in Thorpe Road; this was designed and built in 1870 by George Edmund Street. He was a very prolific architect who built literally dozens of churches all over the country. The church is built in sandstone and has a red tiled roof; there is also a lovely selection of stained glass windows, several of which feature St Stephen. Some of the woodwork in the inner porch and two of the clergy seats in the chancel were carved by the renowned Littlebeck woodworker, Thomas Whittaker, who customarily carved a gnome as his trademark.

ROBIN HOOD'S BAY

After the Norman Conquest of 1066, much of the north of England was abandoned, William the Conquer gave the Fylingdales area to Tancred the Fleming who in turn passed it on to the Abbot of Whitby. The settlements that grew up were about a mile inland from Raw, and by the 1500s there was a settlement known as 'Robin Hoode Baye'.

The village, which consists of a maze of tiny streets, has a long tradition of smuggling and there is reputed to be a network of underground passageways linking various houses together. During the late eighteenth century smuggling was rife on the Yorkshire coast. Vessels arriving from the continent brought contraband which was distributed by contacts on land and financed by syndicates who made vast profits. Tea, gin, rum, brandy and tobacco were among the contraband that was smuggled into Yorkshire from the Netherlands and France in an effort to avoid the duty taxes.

Fishing and farming were among the original occupations that were followed by distant generations of the Bay-folk. Fishing reached its peak in the mid-nineteenth century; fishermen used cobles (flat-bottomed fishing boat) for line fishing in winter and larger boats for herring fishing. Fish were loaded into panniers and men and women would walk or ride over the moorland tracks to Pickering or York to sell it. Many houses in the village were built between 1650 and 1750 and whole families were involved in the fishing industry, with many either owning or part-owning cobles. Later some owned ocean-going craft. During the late 1800s the fishing industry went into decline, and now, the town's income is generated by tourism.

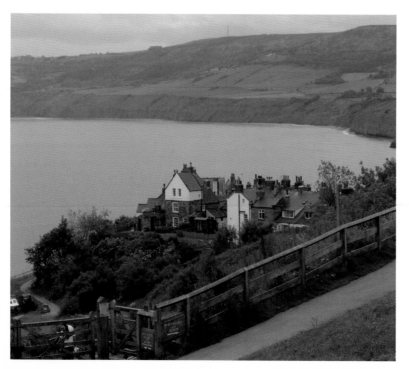

Robin Hood's Bay
The classic view of Robin Hood's Bay looking down from next to the car park at the top of the bank on to the quaint and picturesque cottages below.

Opposite below: **Robin Hood Bay's Cottages and Cobbles**
Looking from the Old Coastguard Station towards Bay's picturesque cottages and cobbled streets (Stokoe Media).

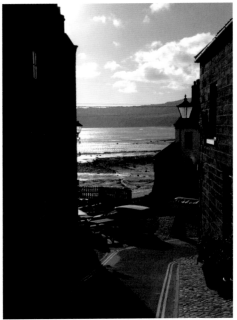

The Laurel Inn

Located halfway down the bank leading to the small harbour and beach, the Laurel Inn was once the haunt of smugglers who used a network of underground tunnels and secret passages to bring contraband ashore (Stokoe Media).

Old Coastguard Station

This photograph is take looking down Kings Street towards the dock and Old Coastguard Station and the sea beyond (Stokoe Media).

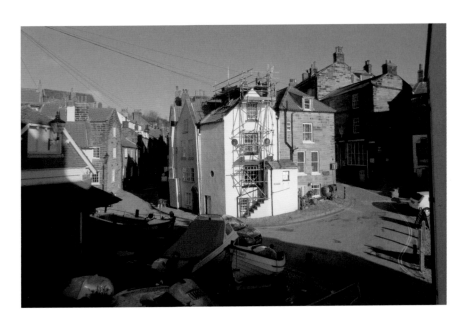

The town was also made famous by the author, Leo Walmsley, as he used Robin Hood's Bay as the setting for his Bramblewick novels which included *Three Fevers* (1932), *Phantom Lobster* (1933), *Foreigners* (1935) and *Sally Lunn* (1937). He was born in Shipley, West Yorkshire in 1912 and two years later the family moved to Robin Hood's Bay. He was in the Royal Flying Corps, based in East Africa during the First World War and he was mentioned in dispatches four times and was awarded the Military Cross. After the war he became an author and settled in Pont Pill near Polruan, Cornwall. He was a very prolific writer with twenty four titles being published between 1914 and 1965.

There are a plethora of cafes, public houses and restaurants in Robin Hood's Bay which can cater for every taste. Probably the most famous pub in the lower part of the town is The Laurel Inn, which must have featured on thousands of postcards and photographs over the years. Sadly, many of the cottages in the village are holiday lets so are sparsely occupied in the winter months.

Old Railway Station
The old railway station in Robin Hood's Bay was turned into a cafe but in more recent years it has been a holiday cottage for letting.

RAVENSCAR

It was in 1640 that Sir Bryan Cooke discovered alum, this was used as a fixing agent in the textile and tanning industries from the mid 1600s right up to the late 1800s. The Peak Alum Works was built at the top of the cliff to extract the alum from the shale. With well over 100 workers living there, this dramatically changed the landscape. The Alum Works made use of an interesting manufacturing process which entailed immersing the raw alum in deep vats filled with human urine. In fact, so much was needed that special ships came up from London filled with vast quantities of it. Two large quarries were dug, with the waste dumped onto large spoil heaps nearby. The finished product was then winched down from the cliff top to a small quay below and loaded onto ships. During the 1800s the demand for alum fell into decline as new synthetic dyes were invented which did not need fixing and consequently the works closed down in 1862.

A brick works was built in the village on the site of the old alum works in 1900, it was originally expected to provide the bricks to build the proposed new town. Ravenscar bricks were used in the building of a new Odeon cinema in Scarborough in the 1930s which is now the Stephen Joseph Theatre, and in the construction of Northstead Housing estate (also in Scarborough). The brickworks ceased trading after the war and the two chimneys were finally demolished in 1960.

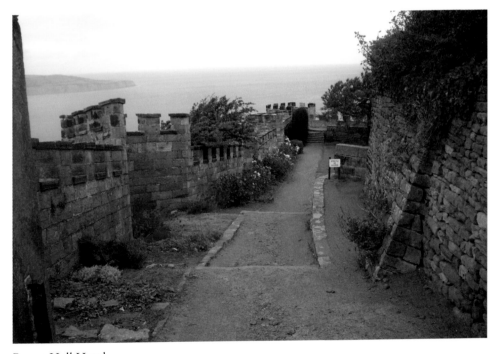

Raven Hall Hotel

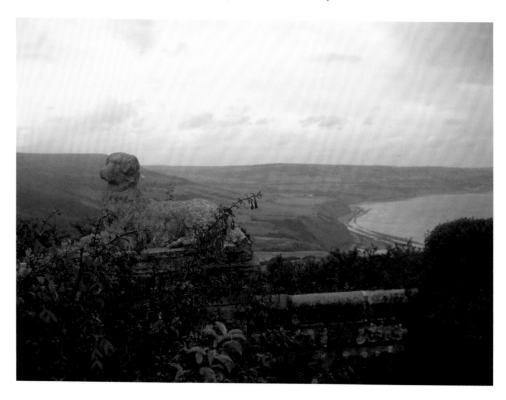

Above: **The Raven Hall Hotel**
This photograph shows the stunning views from the battlements of The Raven Hall Hotel looking towards Robin Hood's Bay.

Left: **Hammond's Folly**
Mr Hammond was a director of the North Eastern Railway Company and was the driving force in bringing the railway to Ravenscar in 1885. Amazingly, he insisted on a 279 yard tunnel being built so the passing trains would not spoil the view from his house.

Opposite: **Robin Hood's Bay**
The stunning view across to Robin Hood's Bay.

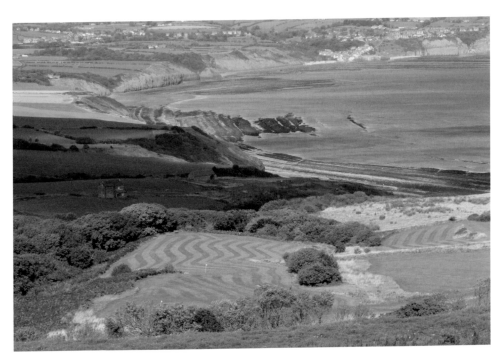

In 1763 Captain William Childs of London became the owner of the Alum Works at Ravenscar and built his home there. In 1774 it was known as Peak Hall and would later become The Raven Hall Hotel. In 1788 the house was bought by Reverend Francis Willis, he was a doctor and became very wealthy treating George III and other Royals – including the Queen of Portugal. When the King died, in 1820, he billed the Royal Court for £20,000 for services rendered. Great improvements were then made to the house including the mock battlements and a formal garden. After Francis' death his son, Reverend Dr. Richard Willis – who was addicted to horse and louse racing – managed to squander the family fortune over a short space of time. In the 1840s he lost the house and gardens to William Hammond of London as a result of a single bet placed on a race between two woodlice across a saucer!

Mr Hammond used the house as a holiday home as he spent most of his time in London. He was, however, not an absentee landlord and quickly became a local benefactor. He built St Hilda's church in the village in 1852 and also the windmill. He was chairman of the North Eastern Railway and, in later life, became obsessed by the Scarborough to Whitby line, making sure it passed through the village and was served by its own railway station. Amazingly, he insisted on having a 279 yard-long tunnel constructed in front of his property so that the line would not spoil the view from his house! Sadly he died in 1885, just three months before the line was completed. After his wife's death in 1890 their four daughters sold it to the Peak Estate Co. for development as a holiday resort. Raven Hall itself was opened as a hotel in 1895 after a massive expansion and in 1897 the village name was changed from Peak to Ravenscar (from the Danish 'Raven Scaur').

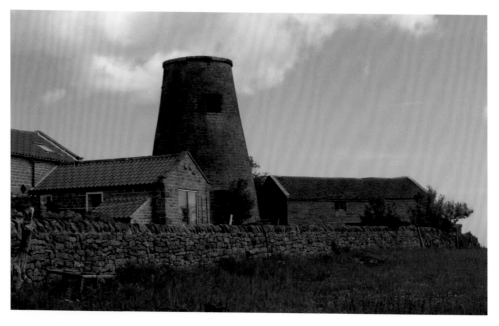

Ravenscar Windmilll

Mr Hammond also built a windmill for the village in the 1850s. It still stands today about half a mile out of the village at the 'Smuggler's Rock' corner.

The Peak Estate Co. soon started work on the proposed new town bringing 300 menin to build the roads and laying drains etc. Building plots were offered for sale in the company's brochure of 1900, special excursion trains were laid on to bring would-be purchasers to the town, with the promise to refund their rail fare if a plot was purchased. Sadly, very few plots were sold so the town was never built – this is why the village is often referred to as 'the town that never was'. It was originally hoped that the village would compete with the nearby towns of Whitby and Scarborough as a holiday destination – if the late Victorian planners had had their way.

Now most of the cliff top, where the proposed town was to be built, and the site of the old alum works and quarries are owned by the National Trust.

SNEATON

The village of Sneaton is three miles from Whitby, according to the 2011 census it has a population of 179. It has its own church, St Hilda's which was rebuilt in 1823. It has its own modern Village Hall which is used by many local organisations. It also has its own public house, The Wilson Arms, which is an historic Grade II listed building that dates back to the eighteenth century and has a relaxed, friendly atmosphere, wooden beams and roaring log fires during the winter months. There are also letting rooms which have wonderful views over the countryside and the sea.

FALLING FOSS

The tea garden at Falling Foss is small but enchanting, it is set in the grounds of Midge Hall, a tiny cottage which nestles close to the magnificent Falling Foss Waterfall in the heart of Sneaton Forest.

The property was originally built as a gamekeeper's cottage in the late 1780s and was subsequently opened as a tea garden in the early 1900s. Unfortunately in the 1960s the property was abandoned and, after a period of fifty years, subsequently became derelict. Steph and Jack Newman bought Midge Hall in spring 2008 and, after completing the renovation works on the property, reopened the Tea Garden for business once again in July 2008.

Falling Foss is situated just below Midge Hall, it is a 30-foot high waterfall which is a spectacular sight, but even more so after heavy rain.

LITTLEBECK

The village of Littlebeck is a beautiful little hamlet at the bottom of a steep-sided wooded valley, there is a ford at the centre of the hamlet where the Little Beck – a minor tributary of the River Esk – runs across the road. Close to the ford is a large tree surrounded with railings to protect it, the inscription on the plaque attached says that it was planted to

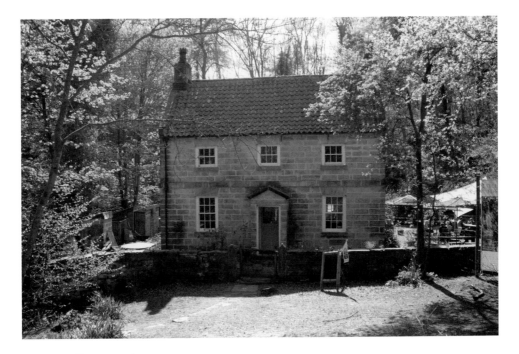

Midge Hall Tea Garden
The tea gardens stand just below the thirty foot high Falling Foss waterfall.

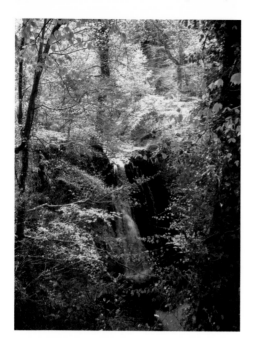

Falling Foss Waterfall

mark the silver jubilee of George V in 1935. On the left-hand side of the road approaching Littlebeck, there is a spring that has been converted into a drinking fountain with an ornate lion's head and three inscriptions, the oldest is dated 1856 reads, 'Man made the trough, the water God bestows then praises his name for the blessing – John Alan 1856', the second reads, 'Weary stranger here you see an emblem of true charity. Richly my bounty I bestow made by a kindly hand to flow, and I have fresh supplies from Heaven for every cup of water given – John Allan 1858', the third reads, 'The stream is pure, as if from heaven it ran, and while praised the Lord, I'll thank the man – A Tramp 1861'.

There has been a Methodist Chapel here since 1890 with the official opening taking place in November that year. Regular Sunday school activities also took place here and a foundation stone for a new schoolroom was laid in May 1904. In the early days, preachers came to the chapel on horseback and a stable was built to house his horse. In around 1948 the stable was converted into a kitchen, until the 1930s lighting was provided by oil lamps with mains electricity coming to the village in 1953.

A famous resident of Littlebeck was the carpenter, Thomas Ernest Whittaker. He was born in March 1910 and worked right up to his death in April 1991, aged eighty-one. It is said that shortly before the Second World War the Quakers of York opened their homes to German-Jewish refugees fleeing the Nazis. Some of these found temporary accommodation with the Whittaker family. One of them was an academic who enjoyed working with Thomas at his workbench. While working with Whittaker, it is said that he told him a story from Teutonic folklore which said that every time that an acorn germinates a gnome is born. The gnome grows with the tree and is its guardian throughout its lifetime. This is clearly the origin of this trademark, and as Thomas only carved in oak, it seems very appropriate that he was eventually known as 'The Gnome Man of Littlebeck!'

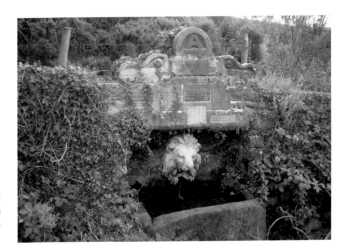

Littlebeck Fountain

This ornate water fountain with water coming out of a lion's mouth can be found just before entering the hamlet of Littlebeck.

Littlebeck Methodist Chapel

The tiny Methodist chapel was opened in 1890 and is still in active use today.

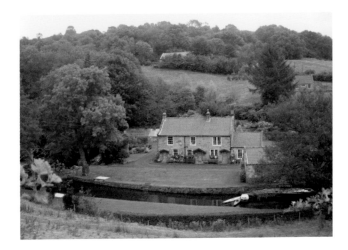

The Fete and Rose Queen Ceremony

The tradition of holding a Fete and Rose Queen Ceremony each August was a begun here in 1954.

The village also holds its annual Fete and Rose Queen Ceremony each August. It is a charming event which has been held since 1954. Each year the local children put on a play on the grass next to the stream that runs through the garden, and the plays are based on popular children's stories, such as Winnie the Pooh and Alice in Wonderland. The Rose Queen is then crowned at the end of it and then floats down the stream on a raft that carries her throne, she will remain the Rose Queen for the year until the next ceremony.

UGGLEBARNBY

Ugglebarnby is a tiny hamlet consisting of just a handful of cottages, a farm and All Saints church which was designed by Noel Armfield and opened in 1872 and built on the site of a Norman chapel which dated from 1137, some of the stonework is from the original church. It is a typical Victorian church built in the Gothic style, with particularly unusual stained glass windows in the nave that depict Judas Iscariot with his purse, which is rare to find in church artwork.

A little further down the road from the church there is an old bungalow called The Cullies that was originally the 'Old Doss House' which, before any state benefits or pensions were introduced, provided shelter for the destitute and elderly farm labourers. They were given work at four pence a day with their food and lodgings thrown in.

Ugglebarnby Millenial
Looking up towards All Saints church, Ugglebarnby, in the distance. In the foreground is one of the village's two new signs, which were installed as part of their millenium celebrations. © Jane Stokoe

IBURNDALE

Iburndale is another tiny hamlet, found half a mile down the hill from Ugglebarnby, there is a narrow stone bridge crossing the beck with a few cottages each side of it. The road then pulls up a steep bank for just under a mile to reach Sleights.

Journey 3

To the Steam Railway, Round the Dale and Back Again

Leaving Whitby on the A171 towards Guisborough, head straight over the Four Lane Ends roundabout on the outskirts of the town andcontinue for another mile passing the new park-and-ride complex on the right and, when you reach, the next large roundabout take the first exit for the A169 that is signposted Sleights and Pickering. Drive down the hill into Sleights and continue through the village until the church is visible on the left. Just after this, turn off onto the road on the right down Eskdaleside signposted for Grosmont, drive for just under three miles along a very twisty narrow road until going down a steep bank into Grosmont. At the centre of the village is a level crossing over the North Yorkshire Moors Railway line. There is a station here with a large car park and tea rooms.

Continue out of Grosmont past the tennis courts that will be on your left, continue over the stone bridge and then up a steep hill for just over a mile to arrive at Egton. When you reach the T-junction, turn left and drive through the village main street and on to Egton Bridge, proceed through the village and follow signs to Esk Valley. After a mile on this road, go past the first sign on the left to Esk Valley and carry on for another mile and take the next turning on the left to Esk Valley opposite this turn off there is a footpath signposted 'Roman Road'. Should you wish to walk and see it, drive on towards Esk Valley for a mile and turn right, down onto the steep bank into the village. Most of the houses here are a found in a row of workers cottages that were built in the early 1800s for ironstone workers.

The village is a dead end, so return back up the hill out of the village. This time turn to the right and follow the road back into Egton Bridge and follow the signs to Glaisdale. When leaving the village follow the road back up onto the A171 Whitby–Guisborough road, turn right and follow the road back into Whitby.

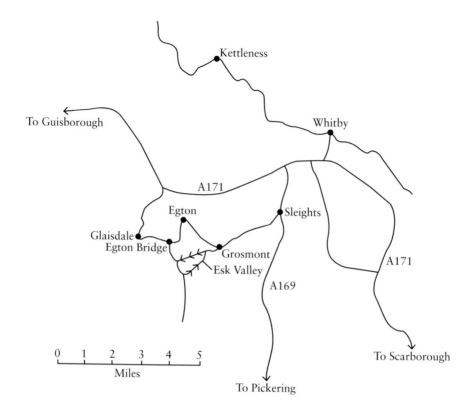

THE NEW PARK-AND-RIDE COMPLEX

The park-and-ride complex has been in operation since 2014 and has room for 450 cars it is almost hidden from view as grassy banks surround the site, but it is well signposted. At the time of writing, the price for an adult return fare was £2.30 and for concessions was £1.15. At this site there is also the well established Victoria Garden Centre and The Stables at Cross Butts Hotel and Restaurant. The Victoria Garden Centre is a substantial complex with a large conservatory that serves as a café with stunning views over the countryside towards Whitby. It is open seven days a week 9 a.m.–5 p.m. weekdays and 10 a.m.–4 p.m. on Sundays.

The Stables at Cross Butts is run by John and Sue Morley and their family and has been operating since 2004 building up a very strong reputation since then. The Morleys were farmers with a prizewinning herd of Holstein Pedigree Cattle. Sadly the farm was hit by the outbreak of foot-and-mouth disease in April 2001 and the whole herd of cattle had to be destroyed. They did restock the farm in late 2001 but they found it hard to continue and obtained planning permission to convert the farm into a restaurant in April 2003 – by 2004 they were up and running. The original restaurant is in the old Cross Butts farmhouse, which is dated at 1691, but a considerable amount of expansion has taken place since then. They now have a wedding licence and hold weddings at the premises on a regular basis, they also have nine luxury ensuite rooms including a honeymoon suite.

The Stables at Cross Butts
Originally a farmhouse which dates back to 1691, this establishment has been a restaurant since 2004.

SLEIGHTS

The village of Sleights is described in many travel books as being the largest village in England, this may well be the case, as it has all the amenities of a small town. The road that progresses down the hill into Sleights on the A169 leads to the bottom of the village, where it crosses the Esk Valley Railway and River Esk over the new bridge which was opened on 26 January 1937 after the old one was washed away in the disastrous floods of 1930. Immediately after the bridge there is a turning to the left down to Sleights Railway Station and the Salmon Leap Hotel. The railway station was designed by George Townsend Andrews and was opened in 1846. It used to have two platforms for up and down line working, but was reduced to single track working in the mid 1980s when the second track was lifted and the signal box closed. The old station master's house on the platform is now a private house. The Salmon Leap Hotel is a modern building that overlooks the River Esk at the weir from which salmon leap when returning to their spawning grounds – hence its name.

The Sleights Horticultural & Industrial Society Show has been held annually since 1880 and is one of the larger village shows in the area. Since 2006 the show has been held on the sports field with classes for produce, fruit, flowers vegetables, crafts, cake decorating, photography, flower arranging etc. Additional attractions include a bouncy castle, face painting, tombola and a fun dog show. Access to the sports ground, which is the venue for the local cricket team, is by a small road close to the Salmon Leap Hotel.

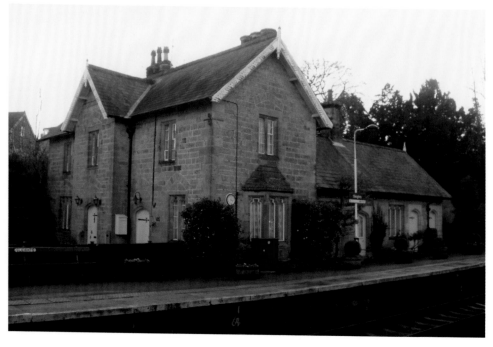

Sleights Railway Station

Sleights Green
A panoramic view of Sleights, taken on the A169 at the top of Sleights Bank.

Continuing up the hill into the village, there is a village green which is covered with a mass of daffodils in the spring, and the Village Hall, or Sleights Institute (as it was originally known), was built in 1910 by George Wilkinson at a cost of approximately £650 and was used as a reading room – the caretaker lived down in the cellar. The foundation stone was laid by Robert Elliot Pannett (1834–1920). During the First World War, Sleights Institute became a Red Cross Hospital for wounded allied soldiers. They were cared for by Dr. T. H. English, a local doctor, and his wife, who supervised the Red Cross nursing staff.

Continuing on up through the village, there are the village shops which include a bakery, Post Office, village store and butcher. Further on up the village there is a fish & chip shop, church, garage and second public house, The Plough, which was once a nineteenth-century coaching inn and now has three letting bedrooms and a restaurant.

The church at the top end of the village is the St John the Evangelist C. of E. church, it was consecrated in 1895 and replaced the previous Georgian church. This earlier church was built between 1762 and 1764 on an adjacent site; it had fallen into disrepair and had become too small due to the growing population of the village. Opposite the church, on the main road, is Church House, this building was built in 1908 and is used for local events and hired by local organisations as a meeting place. The house is located on the corner of the road off the main A169 – called Eskdaleside – which leads on to Grosmont. The new futuristic building on the right-hand side of the road is the English Martyrs Roman Catholic church which was built in 1998 to replace the original corrugated iron roofed building.

Central Stores and Post Office, and the Butcher's Shop

Coach Road

A little further up Coach Road is the old village water pump which has been restored and is enclosed by railings; the village stocks were also located here but have long gone. It is said that, when the pump was in use, care was always taken to have some water in the bucket to start with in case it needed priming!

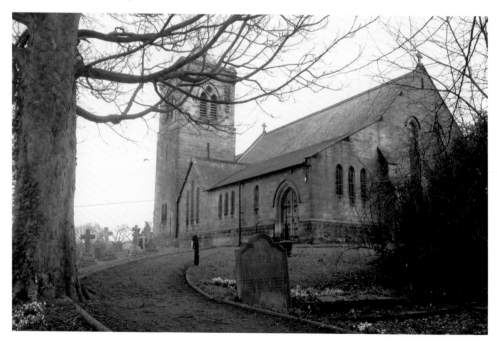

St John's Church of England Church, Sleights
This church was built in 1895.

Church House, Grosmont Road
Church House stands opposite the church on the corner with the Grosmont Road. It was built in 1908 and is in regular use with various local organisations.

Opposite the church on the left is a house called Inkwells, which also backs up onto the A169 at the bottom of Blue Bank, the notorious mile-long 20 per cent gradient hill out of Sleights up onto the North Yorkshire Moors. Inkwells is now a private house, but was originally used as the village school, which was built in 1834 and later enlarged in 1885. The headmaster of the school between 1872 and 1877 was William Stokoe (not a relation of mine, as far as I am aware!). There have been many accidents on Blue Bank after vehicles brakes failed and the school has suffered several near misses, but matters came to a head in 1968 when a runaway lorry left the road ended up in the school playground. The authorities built a new school further down the village. The building now is basically the same, but dormer windows have been added in recent times.

It seems appropriate to mention Edward Simpson known – as 'Flint Jack' – who was born in Sleights exactly 200 years ago in 1815 he was a famous Victorian forger of arrowheads, and other artefacts made from flints and fossils. Many of his forgeries entered into famous collections including the British Museum. In 1846, Jack began drinking heavily and is quoted as saying:

In this year, I took to drinking; the worst job yet. Till then, I was always possessed of five pounds. I have since been in utter poverty, and frequently in great misery and want.

The Blue Bank
This is the view part of the way up Blue Bank at the turning to Littlebeck.

In London in 1859, he was accused of forgery by Professor Tennant who was fascinated by the hard-to-detect forgeries and asked Edward to describe his manufacturing methods to members of the Geological and Archaeological Societies. Sadly, after spending time in prison, he died a pauper.

The radio broadcaster and author George Bramwell Evans – known to some as 'Romany' – lived in Sleights, down by the river in his caravan, with his beloved spaniel, Raj. He also had a cottage in Sleights called Romany Cottage; there is a plaque on the front of the cottage to confirm this. His broadcasts were aimed at children who were enchanted by his nature walks – on which he was constantly accompanied by Raj. Between 1929 and 1944 he wrote eleven 'Romany' books and eight children's books, he died in 1943 aged fifty-nine.

The actor Ian Carmichael was closely linked with the village, married twice, firstly to Jean Pyman 'Pym' McLean, from 1943 until her death in 1983 (they had two daughters, Lee and Sally). Jean was born in Birch Avenue, Sleights, in 1923 and they lived together in Grosmont. There is a commemerative picture in St John's church which reads,

> The flowering cherry trees on the east side of the church were planted in November 1983 in rememberance of Pym Carmichael.

His second wife was the novelist Kate Fenton. The marriage lasted from 1992 until his death in 2010.

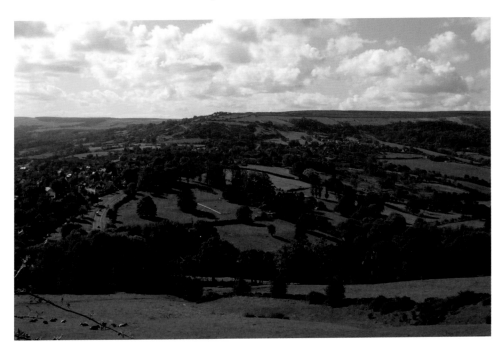

Sleights Panorama
A panoramic view of Sleights, taken on the A169 at the top of Sleights Bank.

GROSMONT

Grosmont is now a tourist village and the site of the most northern station on the North Yorkshire Moors Railway which is a 21 ½ mile railway which runs from Pickering to Grosmont. It is also at the junction of the Network Rail line that runs from Whitby to Middlesbrough. It is now possible to travel all the way from Pickering to Whitby on a steam train at certain times of the year.

An Act of Parliament to build the Pickering to Whitby Railway was obtained in 1833 and, by May 1835, a daily service began on the partially completed line between Whitby and Grosmont. Though the railway company constructed the village, it took another year to complete a tunnel 120 yards long, 14-foot high and 10-foot wide which George Stephenson had to build to continue the line from Grosmont towards Goathland and Pickering. At that time, the village was simply called Tunnel as it had only grown up while the tunnel was being built. The tunnel is still there and is now a pedestrian walkway to the new engine sheds and workshops. The railway company built the post office and the local public house, which at that time was called The Tunnel Inn, but is now called The Station Inn.

Another major problem that Stephenson faced while constructing the line between Beckhole and Goathland was found at Fen Bogs, the area being, as the name suggests, a very wet and boggy area. He came up with the solution of sinking piles into the bog, which was as much as 35-foot deep. He then packed bound sheep skins filled

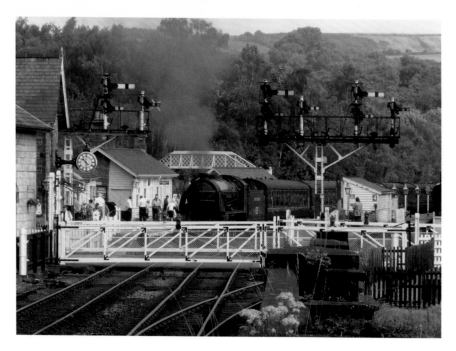

Grosmont Railway Station

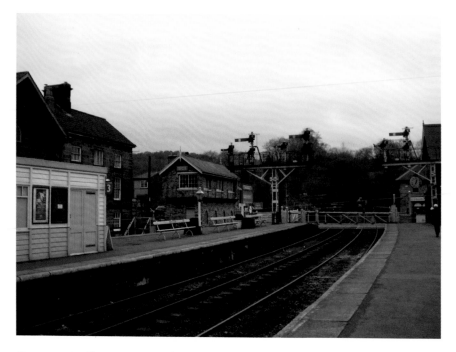

Grosmont Railway Station Platforms
This photograph was taken looking down the Grosmont railway station platform and beyond the shop with the impressive clock outside.

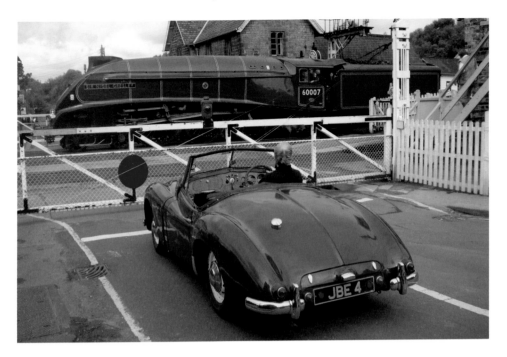

North Yorkshire Moors Railway's 'Vintage Vehicle Weekend'
I was held up in my 1952 Jowett Jupiter at the level-crossing but was delighted to be so when the *Sir Nigel Gresley* steamed past! © Jane Stokoe

with heather and moss, along the direction of the track. It sounds like a rather 'Heath Robinson' (an English cartoonist and illustrator best known for drawings of complicated machines made to achieve simple objectives) solution, but it clearly worked as the line is still in place nearly 180 years later!

At the time the tunnel was being built, ironstone was discovered and within thirty years a huge and thriving iron works had been built up at the site of the modern-day lower car park that is now used by the North Yorkshire Moors Railway and located just outside the village. There were three mines producing 70,000 tons of iron ore per year with blast furnaces processing the ore on site. This industry was short-lived, however, as by 1880 steel making had been discovered, a process that was much cheaper to produce and yielded more durable materials. This new process then began to replace iron, and so the mines started to close, by 1892 almost nothing remained. Some of the old workings (now ruins) are still visible. There is a metal plaque on the side of one brick ruin, thought to be part of the overhead conveyor of ore to the smelter, which gives details of the rise and demise of the industry.

Brick making was also an industry which began in Grosmont in around 1870, at this time there were also brick yards at Danby, Commondale, Ruswarp and Egton. This industry continued right up to 1957. The remaining brick works chimneys were demolished in 1963. The site of the brickworks has since been cleared and twenty-nine houses now occupy it.

EGTON

This village is the home of the Egton Show, which is the largest agricultural show in the Whitby area and has been in existence for well over 100 years. It is held every August and is well attended by locals and holidaymakers. There are two public houses in the village, The Wheatsheaf which dates back to the nineteenth century and Ye Horseshoe Inn which also dates back to a similar time.

St Hilda's church was built in Egton in 1879 and is on the site of an earlier fourteenth-century church, stones in the present church have been salvaged from the former, and there are also some of the earlier stones on display in the entrance of the church. Egton is an important local centre for family history. Prior to 1880, many important birth, marriage and death records were administered from Egton parish and the church in Egton holds detailed transcriptions of parish records. However, the cemetery is half a mile west, at the old church site. After 1870 many parishioners were buried at nearby Aislaby.

EGTON BRIDGE

Egton Bridge is a very picturesque village, complete with stepping stones across the Esk – found by the Horseshoe Hotel (not to be confused with the Ye Horseshoe Inn a mile away in Egton). The Postgate is the second public house in the village and is a traditional country inn which has been in existence since around 1860, it has a selection of en suite bedrooms and its own restaurant, which has won several awards over recent years, it was listed in the top ten in *The Times* top '50 Country Inns with food' award scheme. The Postgate Inn also regularly appeared in the Heartbeat series, under the guise of The Black Dog.

The village hosts the annual Egton Bridge Old Gooseberry Society Show, which is held on the first Tuesday of August each year. This society show is the oldest of its kind in the country, with the first show being held in 1800. At that time gooseberry growing was incredibly popular and competitive shows sprang up all over the country – there was even a national publication *The Gooseberry Growers Register*. It reached a peak in 1845 with 171 shows listed, by 1896 there were only seventy-three shows and by 1915 only eight. Today there is only the Egton Bridge show and about seven small shows in mid Cheshire around Goostrey.

Egton Bridge has strong connections with Father Nicholas Postgate who was born there during a period of immense anti-Catholic sentiment. He was apprehended while carrying out a baptism at the house of Matthew Lyth in Littlebeck, the house was raided during the ceremony and the priest, then aged eighty-two, was condemned to death and was hung, drawn and quartered at York. The Roman Catholic church of St Hedda's is located in the village; in 1797 the Smith family donated land on which a chapel and priest's house were completed the following year. This building became a school in 1867 when the present church was opened. Father Postgate's portable altar stone now hangs at the front of the altar at Saint Joseph's Catholic Church, Pickering, where it is now venerated. Every year since 1974 an open air service has been held – alternately in Egton Bridge and Ugthorpe – in honour of him.

The Postgate Inn, Egton Bridge
The Postgate in Egton Bridge is named after Father Nicholas Postgate who was born here in 1596.

ESK VALLEY

As mentioned previously, Esk Valley is a hamlet of houses which were built in 1873 for the miners and workers at the ironstone mine which ran from 1860 to 1876. It was only in 1951 that a road was built down to the cottages; prior to this the cottages could only be reached by rail. A fortnightly goods train was used to bring in essential supplies until the road was built. Today there is virtually no evidence of this mining activity except for traces of old sidings and mine shafts in fields at the far end of the row of cottages.

GLAISDALE

Glaisdale is an interesting village, as it is in two halves, one lower and the other higher with a gap between them of about a mile. At the lower eastern edge of the village there is the famous Beggar's Bridge, built by Thomas Ferris in 1619. The story goes that Ferris was a poor man who hoped to marry Agnes Richardson, the daughter of a wealthy local squire, and in order to win her hand, planned to set sail from Whitby to make his fortune. On the night that he left, the River Esk was swollen with rainfall and he was unable to cross it to make a last visit to his intended before leaving. He eventually returned from his travels as a rich man and later married the squire's daughter, in later years he built Beggar's Bridge so that no other lovers would be separated as they were!

At this lower end of the village there is a row of stone-built terraced houses and also The Arncliffe Arms, which is on the route of Alfred Wainright's famous Coast to

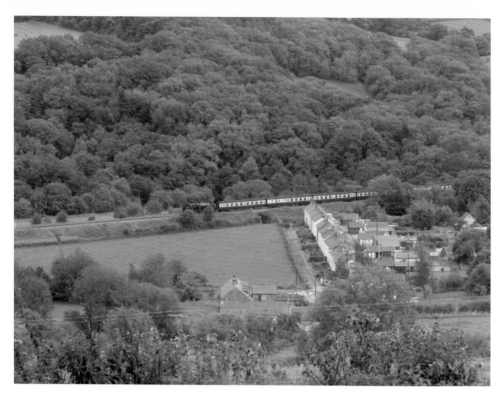

Esk Valley

Essentially a line of cottages built in 1873 for ironstone workers but the workmen did not stay long as the ironstone mines closed in 1876.

Silver Jubilee Flower Display

This seat-cum-flower display was erected here as part of the Queen's Silver Jubilee celebrations in 1977.

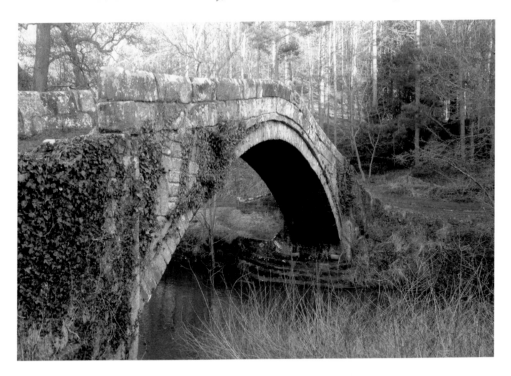

Beggars Bridge, Glaisdale

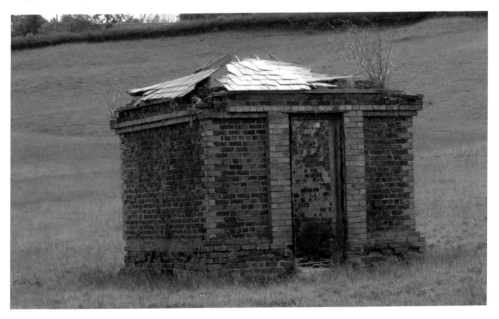

Abandoned Building, Opposite the Arncliffe Arms

This rather sad looking little building is in a field opposite the Arncliffe Arms. I have been told it is where dynamite was stored for use in ironstone or railway building. It has deteriorated greatly over the last ten years and is now occupied by sheep. It would be such a shame if this little building was lost as it is part of our industrial heritage.

Coast Walk, it has six en suite bedrooms and its own restaurant, which serves meals every lunchtime and evening. The menus they use tell more of Tom Ferris and Agnes Richardson,

> Tom was apprenticed to a Hull shipowner and spent some off-duty time with relations at Egton, meeting Agnes at a fair, perhaps at Whitby. Tom sailed from Whitby on 8 May 1588 after which he served with Sir Francis Drake as he beat the Spanish Armada only ten days later, then sailing to the West Indies where he engaged in piracy. He returned to London in 1592, in a captured vessel, still aged only 24, sold the ship and went to Glaisdale as a wealthy man to claim the hand of Agnes Richardson.

What a great story!

The village did in fact have two other public houses until recently. There was the Moon and Sixpence, which closed in the early 2000s and is now a private house and The Mitre at the top of the village, which had been in existence for over 200 years. There had been a bid to convert it in 1999 to a private house as it had been closed for three years but a new owner was found at the last minute. It ran for a short time but closed again, this time permission was given to allow it to become a private house. Sadly, this is such a common occurrence nowadays.

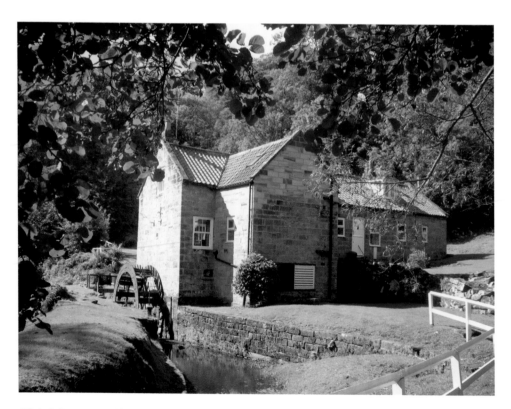

Glaisdale Watermill

At the top end of the village there are more shops including a butcher and post office and also the imposing Robinson Institute, the land and money was gifted to Glaisdale by Thomas Alexander Robinson of Ferriby in 1913 to build a Reading Room and Library and to be called the Institute. It was built to celebrate the coronation of George V in 1911. The Robinsons were very successful business people in Hull and had a very large residence in Glaisdale. The present permanent stage was built in 1958 when a small extension to the committee room was incorporated to make the kitchen. The trustees obtained a Lottery Fund Grant of £332,000 in September 2003 to build an extended store room and completely refurbish the Kitchen, toilets and re-roof the building. This work was done during 2004 and the building reopened to the public in January 2005 and at the official reopening event, a great-great-grandson of the original benefactor, also called Robinson, was able to attend. The Robinson Institute is now also the home of the Esk Valley Theatre, where a new production is put on each year.

St Thomas' church dates from 1793 and replaced the 'Chappell of Glaisdale', a cruciform straw-thatched building, for which a date stone of 1585 can be seen laid within the side of the steps leading to the present tower. Thomas Ferries, alderman of Hull, the builder of Beggar's Bridge over the Esk at Glaisdale in 1619 left a bequest for the repair of the chapel and provision of minister. In 1792 the old chapel was demolished and the present building erected and opened in 1793 (the date can be seen

The Robinson Institute
The institute was built in celebration of the coronation of George V in 1911; it is now the home of the Esk Valley Theatre who put on a new production every year.

Glaisdale War Memorial
At the centre of Glaisdale is the war memorial; the road to the left leads to Glaisdale Dale.

on the South wall sundial). The nave originally had galleries on three sides, but only the West gallery, housing the organ, remains.

GLAISDALE DALE

At the top end of the village there is a road out leading out of the village to Glaisdale Dale, at this junction there is also the War Memorial and village hall. I took the library van to Glaisdale stopping at the Arncliffe Arms and the Robinson Institute, I then went round Glaisdale Dale. This is a circular route that runs for about three or four miles, I called at nine farms on the way round. I have mentioned this as the views round this Dale are spectacular, some of the best in the whole area. About a mile out of the village is the Glaisdale Head Methodist chapel, this is a charming little chapel which was built in 1821 and is well worth a visit.

Glaisdale Methodist Chapel

Glaisdale Dale Road

Glaisdale Signpost
At the top end of Glaisdale Dale there is a turning off to Rosedale, this is a lovely old cast-iron sign showing the way to go.

Journey 4

To the Wilds of Westerdale & Commondale

Leaving Whitby on the A171 towards Guisborough, proceed straight over the Four Lane Ends roundabout on the outskirts of town and carry on in this direction for a further mile past the new park-and-ride car park on the right and on to the large roundabout at which point take the second turning and continue towards Guisborough, continue this way for 10 miles and then take a left turn down to Lealholm, making your way through to Danby and then to Castleton. Follow signs to Westerdale and then continue on over Commondale Moor and into Commondale. When leaving the village, drive up the hill past the Tea Rooms on the right, then past the red brick church on the left and back up onto the A171, and then follow the road back to Whitby.

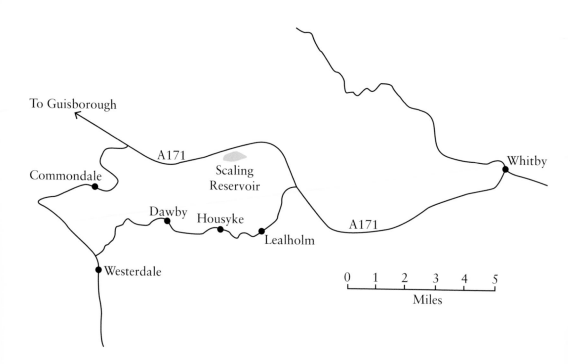

LEALHOLM

Lealholm is regarded by many as being one of the most beautiful villages in North Yorkshire. It has everything:a fine church, stone cottages, a village green complete with a quoits pitch opposite the local public house, bakery and stepping stones crossing over the river.

Lealholm Agricultural Show is held on the first Saturday in September on the village sports field, usually reserved for cricket during the summer months, and football during winter. It has over 200 craft exhibits, including wine making, fruit, vegetables and farm produce all vying for competition and includes categories for children's participation.

The Board Inn is the local village inn and has been operating since 1742, it has been run by Karen and Alistair Dean who have been the landlords since 2008. They and their pub have appeared in many local and national publications including the *Yorkshire Post*, *The Daily Telegraph*, *The Good Beer Guide* and *The Spectator*. The restaurant, which uses only local produce, now has a great reputation. The *Yorkshire Post* said that 'it is now impossible to get a table unless you book well in advance'. They also have their own fishing rights. There are two water fountains in the village, both erected in 1904, one on the village green near to the church and the Board Inn, and the other being situated a little further down the road close to the village garage. *The Sunday Times* once described Lealholm as 'the prettiest village in Yorkshire'.

Lealholm Stepping Stones

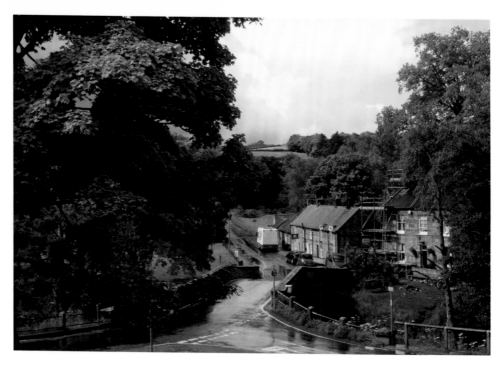

Lealholm Green with the Board Inn to the Right

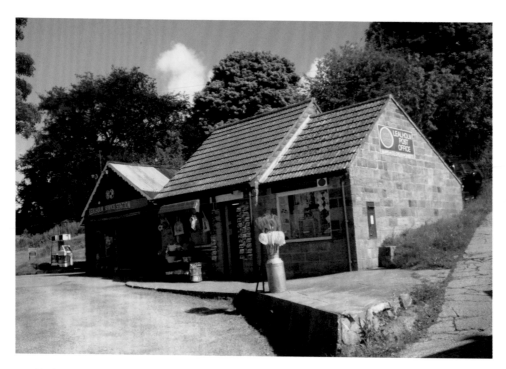

Lealholm Village Garage and Post Office

The railway station was opened on 2 October 1865, and is located on a stretch of line between Castleton and Glaisdale which has always been single track. Lealholm used to have a passing loop at the station where freight trains could pass passenger trains. The remains of a disused platform are clearly visible, though now completely overgrown, there also used to be a signal box at the station, long since demolished. Trains stop at the main station platform where the stationmaster's house is situated; this is now a private house. Only a small internal shelter remains in the station platform. Today, the line is generally quiet except for the school train on a morning and early evening. A goods shed and coal yard located close to the railway station later became a factory base when the company Lightspeed Panels was set up in 1972 they produced the Magenta kit car, a fibreglass body kit that was based on a Mini chassis; today the site is a car repair garage.

The village has three churches. St James' C. of E. church, a relatively new church, was built at the end of the nineteenth century. Sir Francis Ley became the chief benefactor of this church when it was initially proposed for construction upon land given by Viscount Downe in 1881; the foundation stone was laid in 1901 and the building completed and consecrated by the Archbishop of York in 1902.

St James' Church
In the foreground is one of two water fountains installed in 1904, and behind it is the village war memorial.

Our Lady of the Sacred Heart Roman Catholic church is even younger than St James'. In September 1931, local Catholics raised sufficient funds to build a church in the village and Bishop Shine later laid the foundation stone. The church is surfaced with coursed rock-faced stone that supports a Welsh slate roof with a cross on the west gable.

The Methodist chapel has been using the same building in the village since 1839.

LEALHOLMSIDE

Overlooking the village of Lealholm is the hamlet of Lealholmside, which is a row of approximately twenty-five houses running along the side of the valley. It is not surprising that this area was such a popular location with the Victorian photographer Frank Meadow Sutcliffe, who took a large number of pictures in the area, although few of those featuring hamlet itself are in publication.

On Friday 27 April 1979, a United States Air Force Phantom aircraft from Alconbury was performing low level tactical reconnaissance over the North York Moors when the engine stalled. The aircraft banked to the left, striking the ground to the west of Lealholmside before cartwheeling in a fireball across fields for almost half a mile. Plt Maj. Donald Lee Schuyler and Navigator Lt Thomas Wheeler were killed in the crash.

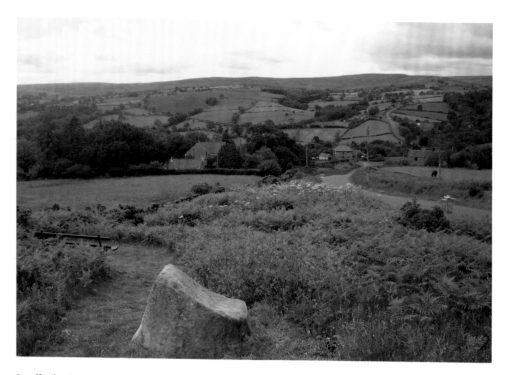

Lealholm Monument
The stone in the foreground of this photograph is a monument to two American pilots who were killed when their plane crashed in 1979.

It is believed that the crew carefully guided the stricken craft away from the village, where the local primary school was full of children who begun classes just half an hour before the accident. A memorial stone, erected by grateful villagers, stands on the site of the crash, alongside the road between Lealholm and Lealholmside.

DANBY

The village of Danby has its own railway station and is part of the Esk Valley line that travels from Whitby to Middlesbrough, the villages served by this line include, Ruswarp, Sleights, Grosmont, Egton, Glaisdale, Danby, Castleton, Commondale and Kildale. The Stonehouse Bakery, tearoom and cake shop is very popular with locals and tourists alike with home-made food, cake and jams. The local pub is the Duke of Wellington which is an eighteenth-century ivy-clad inn; it has a restaurant and eight en suite bedrooms for bed & breakfast customers. Danby has its own Village Hall, which is thirty feet by fifty feet and boasts an additional stage at one end, and is an ideal venue for wedding receptions, dances, parties etc. Like many villages in the area, Scotch Blackface sheep roam freely upon the village green, keeping the grass down all year round – which is cheaper than employing gardeners!

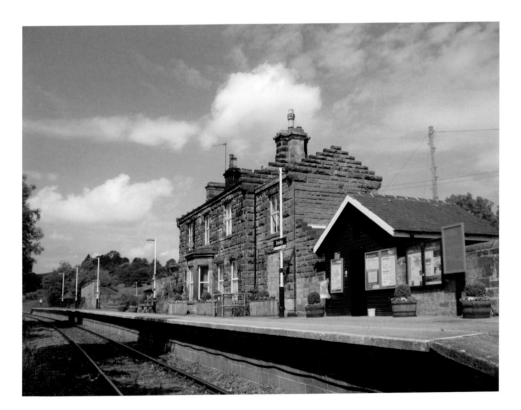

Danby Railway Station

There is also a brand new surgery and medical centre that serves the village and surrounding area. The village also has its own fire station and C. of E. primary school, which has recently been extended, as it has a very good reputation, with children attending from a very large catchment area.

The village church is St Hilda's and dates back to the fifteenth century, although earlier churches going back to Saxon times previously occupied this site. There have been several restorations of the church, these occurred in 1777, 1808, 1829 and 1903, the last restoration being in memory of Canon Atkinson in an effort to restore the church to its original early English appearance. Danby Methodist Chapel was built in 1811 and, as a result of growing congregations, a gallery was installed in 1846. The manse was built adjoining the chapel in 1857 when further expansion took place in 1887 when a two-story extension to the chapel was built comprising a vestry and boiler room with Sunday schoolroom above. In 1950, an extension was added providing a kitchen above and a suite of modern toilets.

On the outskirts of the village is the Danby Visitors Centre. This was originally a hunting lodge, but is now an information centre set in thirteen acres of its own land with forest trails, etc. There is plenty of information there about the natural history of the moor and its wildlife, maps and local walk leaflets about the Moors Centre and the Danby Estate.

The Danby Beacon was one of a line of beacons that dated back to the 1600s when the country was living under the threat of invasion from France. It was to have been lit when a soldier stationed nearby caught sight of a foreign fleet. Danby Beacon is now a national landmark, which is used as a reference point by thousands of visitors and walkers each year. Over the years, the old wooden beacon aged so much that it eventually disintegrated and fell down. A new beacon was unveiled in 2008 by Lord Downe, the president of the Danby Beacon Trust. During the Second World War, the site became home to one of the first radar stations guarding the north east coast.

Danby Castle is a mile outside the village. Located at Danby Rigg, it was built in the fourteenth century for Lord Latimer, who was a man of great wealth, following a particularly interesting architectural design that combined defence and comfortable living. Catherine Parr once lived at the castle, before she became the sixth wife of Henry VIII. The castle is a working farm today and part of the building is a farmhouse and is often used as a wedding reception venue.

The Danby Agricultural Show is held every August, another typical country show with traditional country entertainments and activities, including exhibitions of farm animals such as sheep and cattle and chickens, show jumping and displays of farm machinery, as well as craft and produce competitions.

BOTTON VILLAGE

I mention Botton Village here as an additional location to visit while passing through Danby, at the school there is a narrow road at the side of it that leads to Botton Village two miles away. It is a community for people with learning disabilities which was

Botton Village
The village was established in 1955 for people with learning difficulties.

formed in 1955, today it has a population of 280, 130 of whom are adults with learning disabilities. All of the residents live in large houses with one or more houseparents. There are five farms located around the village. The villagers, as the adults with learning disabilities are called, work on these farms with the help of co-workers who supervise their work. In the village there are many different workshops where villagers make products which are sold to the public via a number of outlets. There are also three shops: a gift shop for visitors, a village store, which is the village food shop and a coffee bar where the villagers and co-workers congregate in the evening.

I used to take the mobile library here, which I greatly enjoyed. This was in fact the last stop that I made with the van on 16 September 2011, later that evening mobile libraries in North Yorkshire were withdrawn from service, this was a sad day for me and many of the villagers. If you have visited Botton, to leave, simply retrace your steps back into Danby to pick up the original route again.

CASTLETON

Like Glaisdale, Castleton is a village in two halves. The lower part, just off Casleton Moor has the railway station, the Eskdale Inn (opposite the station) is a newly built

residential home. Moving up to the higher part of the village requires crossing the River Esk over the stone bridge next to The Eskdale Inn and carrying on up the winding hill for half a mile or so. This larger part of the village is where most of the shops and The Downe Arms with the bowling green next to it are located. This pub, which was refurbished in 2013, has three en suite bed rooms and a restaurant and features in the 'Good Beer Guide' for 2015. The Eskdale Inn is a Victorian inn built in 1870 with two en suite bedrooms and a restaurant and beer garden.

The village also has its own garage, village shops, art gallery, tea rooms, hair dresser and post office. There are two churches in the village the C. of E. St Michael and St George church, built in memory of the local men who died in the First World War. The benches, organ screen and panelling at each side of the altar all bear the distinctive signature of a crouching mouse of Robert Thompson, the 'Mouseman of Kilburn'; the second church being the Castleton Methodist which is situated in the High Street.

Castleton Moor railway station was opened in April 1861, the line was extended eastwards to Grosmont four years later, and eventually, right through to Middlesbrough. The line was built with a single track and the station provided with two platforms as it was the location of one of the route's passing loops. A signal box was also built. Goods services over this route were finally withdrawn in 1982 and, though the goods shed can still be seen, the signal box has since been demolished.

Castleton Green Millenium Monument
On the Castleton Green is this millennium monument with the quote, 'To everything there is a season and a time for every purpose under the heaven'.

Like many other villages in the area, ironstone mining and smelting took place here at the quarry that existed on top of the hill north of the river. The stone was transported down the hillside by a long conveyor belt that ran to the station at the bottom of the valley where it was picked up by goods trains.

The Castleton and Danby Floral and Horticultural Society Annual Show is held on the second Saturday in September.

WESTERDALE

The village of Westerdale consists of a single broad street of around twenty five houses and cottages set well back from the road to the north east of a small stream that joins the Esk near Hunters Sty bridge. There is a church called Christ Church, and a small, disused, Weslyan chapel, close to the church is the Village Hall. This was originally the small schoolhouse, which dates back to about 1873. The building was closed as a school in 1953 and later became the village hall in the early 1970s. Other amenities in the village amount to a post box and a phone box – this may well be still used as there is no mobile phone signal in the village! The 2011 census gave a population of 149.

Westerdale Millenium Cross
This seems to have been a great achievement to erect as there are only about 25 houses in the village.

Westerdale Moor is an extensive upland area that surrounds the farmland in Westerdale. At its highest it rises to 429 metres in the vicinity of Ralph Cross, and Baysdale Moor, to the south west, reaches 433 metres at Stony Ridge, which is the second highest point of the North York Moors.

Westerdale Hall is a substantial stone and slate-roofed building, located close to the west side of the village, originally owned by the Duncombe family it was designed by Thomas Henry Wyatt and built as a shooting lodge – mainly for grouse shooting in the late summer and autumn. After the Second World War it became a popular youth hostel but is now a private residence with many of its original external features remaining intact. Close by is Hunter's Sty Bridge, a restored packhorse bridge with original paving and arching. The church, chapel and former school are rather tucked away, but are all worth visiting.

COMMONDALE

Commondale is an interesting village in upper Eskdale; it has a considerable number of red brick buildings, more built with these bricks than from the traditional stone. This is probably due to the fact that the village once had its own brick works, which produced both pottery and bricks right up to the 1950s. In the early 1800s mine shafts were

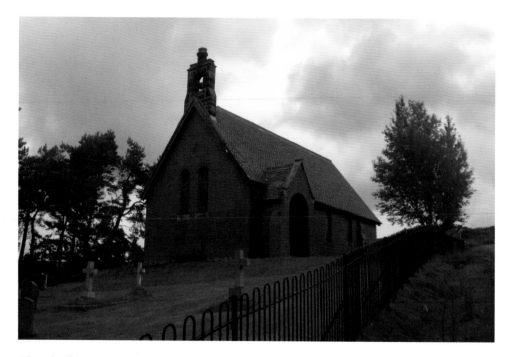

Church of St Peter
This is the charming little church in Commondale was built using the locally produced red bricks in 1898.

Stained Glass Windows of the Church of St Peter, Commondale
These beautiful modern-looking stained glass windows depict St Colman the Bishop of Linisfarne

opened in a search for ironstone, but this never developed into full-scale production. There are also the remains of old lime kilns and a bleach mill on the moor above the village. Here, wool gathered from local sheep would be pegged out so that the sun could bleach it.

The charming and tiny church of St Peter was built in 1898 out of the local red brick, it is rectangular in shape, but for some reason the bell tower is made of the local stone. It was built to serve the increased population of Commondale, many of whom were employed at the local brick and pipe works. There are three beautiful, modern-ooking stained glass windows depicting St Colman, the Bishop of Lindisfarne. At the centre of the village is the Cleveland Inn and the village War Memorial; it is a sobering thought to think that even this tiny village, secluded in such a beautiful area, did not escape the horrors of the First World War.

The village is served by the Northern Rail line from Whitby to Middlesbrough and has its own tiny railway station!

Journey 5

Over the Moors and Back to the Coast

Leaving Whitby on the A171 towards Guisborough, head straight over the Four Lane Ends roundabout at the outskirts of town and continue for another mile past the new park-and-ride and at the next large roundabout take the second exit. After a few hundred yards, take the left turn that is signposted for Aislaby and continue beyond the village and bear to the right and rejoin the A171, turn left towards Guisborough. Carry on for just over five miles before taking the first right-hand turn to Ugthorpe, from this point the village is less than a mile ahead. After looking round the village, return back to the A171 and carry on towards Guisborough. Two miles from this point Scaling Dam is visible on the left, turn right here at the sign for Roxby and continue for just under two miles before making your way past a row of cottages on the right known as Turton Cottages then. Proceed straight past the Fox Inn and then down the bank into Roxby. At the end of the village the church comes into view, continue on as the road bears to the right, carry on up the bank past the Fox & Hound pub on the left until the road then joins the A174 coast road to Whitby.

Turn right here and then, almost immediately after, turn left into Staithes. There is a large car park at the top of the bank leading down to the old part of the village, as vehicular access is only available to local residents. When leaving, head back to the A174 and continue on towards Hinderwell. At this point, turn left to Runswick Bay, as this is another very attractive coastal village. Down the steep bank there is a car park located very close to the village – which would save another brisk walk! Then go back on to the A174 again and continue on towards Whitby, the next village on is Lythe, but just before that there is a turning to the left to Goldsbrough and Kettleness, both of which are worth a visit.

Travel down Lythe Bank, admiring the stunning coastline view as you go, into the village of Sandsend, which is a very picturesque village overlooking the sea. From here it is a two mile drive back to Whitby, the route to which passes the Golf Course on the left and Raithwaite Hall on the right.

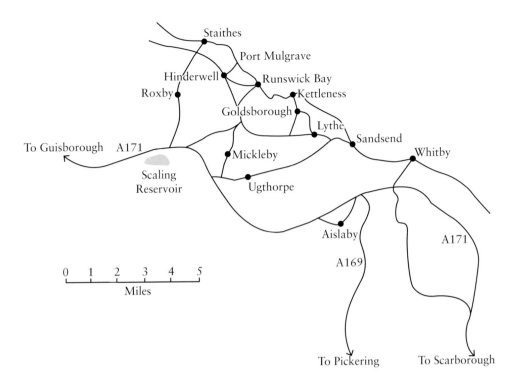

AISLABY

Aislaby is a long village of stone built houses located three miles to the west of Whitby upon a hillside overlooking the River Esk and Sleights . The church of St. Margaret was built in 1897 on the site of an earlier chapel that was built in 1732, which itself replaced a medieval chapel. The new church stands at the western end of the village, with the chapel along the road to the east. This Chapel was built before 1170 though fell to ruins and was rebuilt in 1732 with a gallery erected in 1752.

The mill, which had been in existence since the twelfth century, was built on the riverside and survived until the nineteenth century. It was close to Strait Lane, which follows the route of an ancient causeway from the Esk. At the other end of the village is the narrow Featherbed Lane, which was once said to be the narrowest 'King's Highway' in Britain and is now a footpath, sometimes overgrown, which leads down to Sleights and Briggswath.

The village pub is The Forge, an eighteenth-century inn which was known as The Huntsman until it closed for some years but reopened again in 2012. The name changed at that time to reflect the fact that the village blacksmith's shop was located in front of the pub. They offer lunchtime and evening meals seven days a week.

Aislaby Hall is at the start of the village with spectacular views over the Esk Valley, it was built in the early 1800s and was updated and added to in the early 1900s. The Hall, front wall and gate piers are Grade II listed. The property is now owned by a holiday letting agent and can be hired out as holiday accommodation.

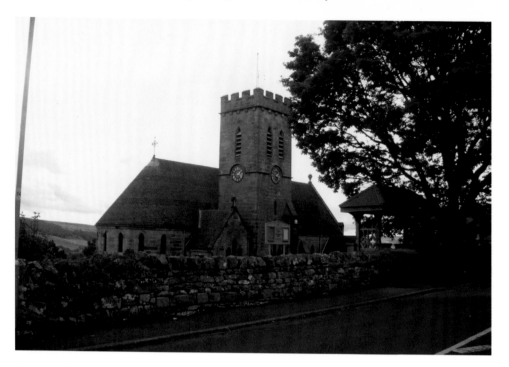

Church of St Margaret Aislaby
This church was built in 1897 on the site of an earlier chapel built in 1732.

UGTHORPE

When driving into Ugthorpe, the first building that comes into view is Ugthorpe Mill, which has been recorded in Ugthorpe since 1776 – though there has been a mill on the site since the thirteenth century. The mill would once have been run by the Lord of the Manor as, in medieval times, peasants were not allowed to mill their own bread. The village has two churches, St Anne's Roman Catholic church and Christ Church (C. of E.). St Anne's is on the site of an old Victorian boarding school which was built in 1855 and eventually closed in 1970. Also built in 1855, Christ Church sits on the opposite side of the road to St Anne's and was consecrated by the Archbishop of York on 13 August 1857.

Another site of interest in the village is the Ugthorpe pin-fold, which dates back to at least the 1700s, the pin-fold was used to impound livestock that had strayed onto the lanes or cultivated fields from the surrounding moorland and common pastures.

Stray animals could be a real hazard; to prevent injury or damage these animals would be captured by an appointed person called a Pinder. He would put the animals into the pin-fold and the offending owner would have to pay a small fine known as 'poundage' in order to retrieve them. Many pin-folds continued to be used right into the twentieth century, although the collecting of fines had died out by the early 1900s. This particular pin-fold has recently been restored and comes complete with carved wooden sheep!

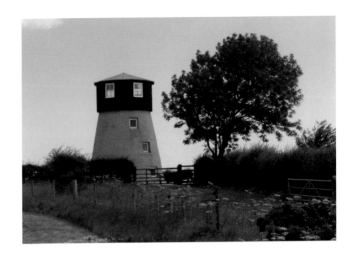

Ugthorpe Windmill

Ugthorpe Pinfold

This is the recently restored Ugthorpe Pinfold which dates back to at least 1700. It was used to impound stray animals; the farmer would have to pay a small fine to retrieve them.

Mickleby Golden Jubilee Seat

A very short distance from Ugthorpe is Mickleby, which according to the 2011 census has a population of 283. As part of their Queen's Golden Jubilee celebrations they commissioned this charming seat, water pump and flower bed.

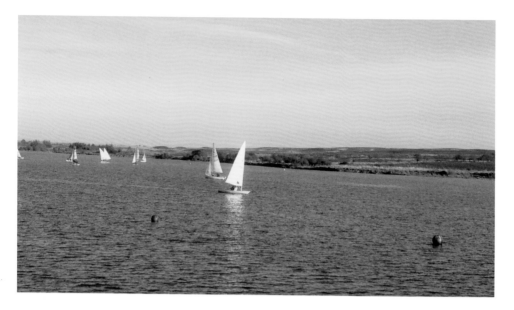

SCALING DAM RESERVOIR

The reservoir at Scaling Dam was built in 1957 and is 180 metres above sea level and just under a mile long. Its close proximity to the east coast means that it is particularly important for passing migratory birds on their journey either to or from their summer breeding grounds. This is the largest area of inland water on the North Yorkshire Moors and there are paths running around the perimeter of the reservoir to enable bird watchers to view the visiting birds from close quarters. Fishing and sailing permits are available from the club house and there is also a picnic area, car park and café.

The shallower western end of the reservoir was established as a nature reserve in 1969. The rest is used for a variety of water sports including sailing and canoeing; angling is also popular, though all boats and anglers are excluded from the nature reserve at all times. The sailing season runs from March until the end of October. Boats are kept off the water during the winter months, to avoid disturbance to the numerous wintering wildfowl.

ROXBY

Heading towards the village of Roxby there is a row of cottages on the right, just before the road banks down into the village, called the Turton Cottages. These were built in 1858, the building complex comprises of two ranges of cottages which are connected by a central block with a horseshoe shaped door to allow access to the rear of the property. The estate of Roxby was bought by J. Turton Esq. M. D. who was the physician to George III. He died in 1806 without issue and his estates were passed to Edmund Peters, who then changed his name and arms to Turton. The horseshoe doorway was the entrance to the blacksmith's shop that used to serve the area.

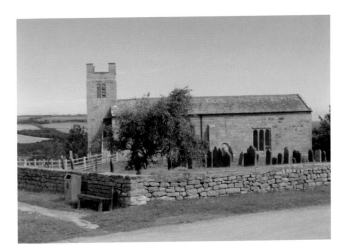

Opposite: Scaling Dam
The reservoir at Scaling Dam
is now a popular water sports
centre, and part of the reservoir is
now a nature reserve for migrant
birds.

Top: Turton Cottages, Roxby
The Turton Cottages are visible
on the right. They were built in
1858. The horseshoe door in the
centre was originally the entrance
to the blacksmith's shop. © Jane
Stokoe

Middle: St Nicholas's Church,
Roxby

Bottom: Borrowby, Looking
Towards Staithes and the North
Sea

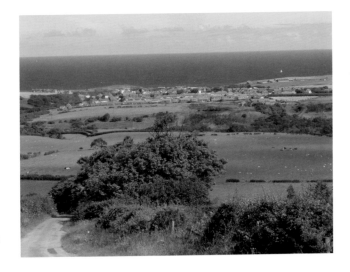

St Nicholas' church, Roxby, was largely rebuilt in 1818, and has a simple main building, with a square tower at the western end. The church contains a brass monument to Thomas Boynton who died 1523, who took credit for first hallowing the church. There are also monuments to Frances Lady Boynton who died in 1634 and Katherine Lady Ingram, a daughter of Thomas Fairfax who died in 1666.

DALE HOUSE

A small hamlet of cottages on the outskirts of Staithes, there is also a public house called The Fox & Hounds, a nineteenth-century inn.

STAITHES

The village of Staithes is split in two halves. There is the modern part built on the main road between Whitby and Saltburn on the cliff tops above the original fishing village which is at the bottom of the steep bank. This was once one of the largest fishing ports on the North East coast, but is now a favourite location on the tourist trail; this along with Robin Hood's Bay, must be the most photographed village on this coastline. The young James Cook was apprenticed to a grocer here and must have been inspired by the local fishermen visiting the shop, as it was not long until he moved on from the village to Whitby, where he would be later apprenticed to John Walker, a Whitby ship owner.

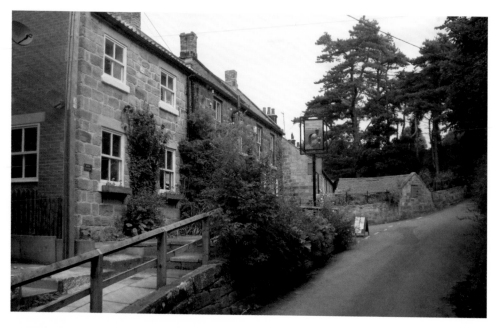

The Fox & Hounds Pub, Dale House

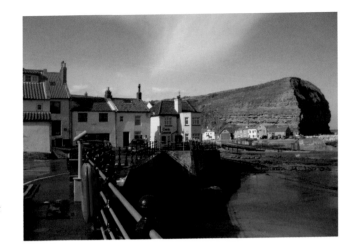

The Cod & Lobster
Near Staithes harbour looking towards the famous Cod & Lobster pub with the headland at Cow Bar in the distance. © Jane Stokoe

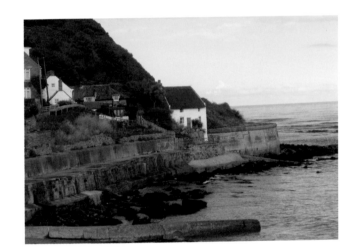

Runswick Bay
This little cottage in Runswick Bay must have appeared on thousands of photographs and postcards over the years being in such an idyllic location. © Jane Stokoe

Runswick Bay Vista
© Jane Stokoe

There are plenty of cafes, restaurants and public houses in the village, the most famous, is The Cod & Lobster, which has been in business since Victorian times. Before leaving, cross over the metal footbridge to Cow Bar and walk down past the Lifeboat Station – the views here are excellent.

The old railway station, now a private house, is situated at the top of the village, beside the car park and . The railway line came down from Middlesbrough and continued through to Whitby and Scarborough. The Whitby, Redcar and Middlesbrough Union Railway was formed in 1866, but, due to the difficult terrain which required many tunnels and viaducts, it was not until 1883 before the line was completed. The line crossed the A174 by the junction of Cow Bar Lane before passing over the 150-foot deep valley via the 700-foot long viaduct made of concrete and iron. The viaduct was totally exposed to gales and bad weather coming in off the North Sea so a bell would be rung in bad windy conditions to impose a 20 mph speed restriction. The viaduct is long gone, but the bell is now on display in the National Railway Museum in York.

The village has for a long time been an inspiration to artists, in particular the impressionist colony known as the 'Staithes Group' which included Laura and Harold Knight, Fred W. Jackson and Arthur Friedenson, who lived there from 1880 to 1914. Artists still come in large numbers; they and their work are much in evidence in and around the village.

Staithes was the filming location for the hit children's BBC TV programme *Old Jack's Boat* starring Bernard Cribbins and Freema Agyeman; the first series was filmed in 2013 and the second in 2014. One of the holiday cottages in Cow Bar was used in the series as Old Jack's house.

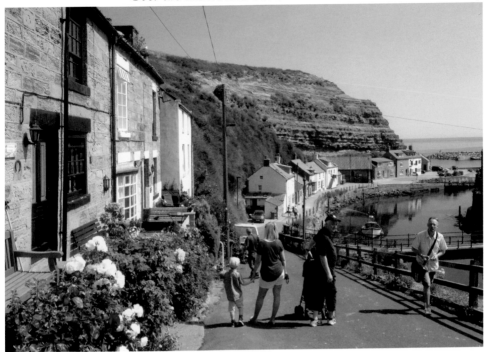

Opposite: **The Bridge Over Cow Bar Nab**
The house with black window frames is the one used as 'Old Jack's' house in the children's TV series *Old Jack's Boat*. © Jane Stokoe

Above: **Cow Bar from Old Jack's House**
© Jane Stokoe

GOLDSBOROUGH

Goldsborough is one of a series of fourth-century signal stations built along the North East coast between Flamborough Head and the River Tees. These were employed to provide the Roman garrison with advance warning of marauding Scottish or Saxon raiders. Each station conformed to the same design, consisting of a central tower surrounded by a wall enclosing an area 90 metres square. A beacon, sending signals of fire or drifting smoke from the top of the tower, could be spotted from the next station. The signals were relayed to navy bases in the Tyne and Humber estuaries, and to a cavalry unit at Malton, allowing Roman forces to intercept the invaders, this strategy was well-planned and effective. Over 300 coins were found at the Goldsborough site when it was excavated at the end of the First World War. The dates on them indicate the signal station here was occupied between AD 368 and AD 395. Other evidence suggests that Goldsborough might have been ransacked and later abandoned.

Turning off the A174 towards Goldsborough, a few hundred yards further on is the site of an RAF station and bunker that had been developed during 1941–42 for the detection and plotting of shipping and by 1945 radar was also installed. In 1951 it

The Goldsborough Bunker
The remains of the RAF radar station developed during the Second World War

was upgraded as part of the Rotar project to build underground protected operations rooms along the east and west coasts of the UK.

The greatest threat to the country at this time was thought to be from the east, so the east coast sites tended to have more underground operations areas. The bunker had 10-foot thick ferrocement walls, complete with its own borehole, generators and filtered air conditioning. These bunkers were supposed to give protection against a near miss by a nuclear weapon. The distinctive feature of the east coast sites was the bungalow, which served as a guardroom for the bunker. The bungalow concealed an access corridor, which led to the bunker.

The Goldsborough bunker was destroyed by a severe fire in March 1958, initially the news of it was repressed and only some months later were the *Whitby Gazette* allowed to report it. Although the technical site became unusable, the domestic site, located nearby, continued to be used and housed shift and construction workers from nearby Fylingdales. It was used more recently by North Yorkshire County Council as a teacher training centre. The guardhouse, which has in recent years been used as a hostel, is now derelict. Vandals have repeatedly set fire to the building and the roof has fallen in and all interiors have gone.

The village itself only has a handful of cottages and farm buildings and the Fox & Hounds country inn. Jason and Sue Davies saw the property advertised in the *Whitby Gazette* around ten years ago and since that time they have built up a fine reputation in the area.

Kettleness Railway Station
This building is now used as an activity centre by the scouts. © Jane Stokoe

KETTLENESS

Kettleness is described in various guidebooks as being the most remote village in the country; it is a hamlet on the coast and was once a stop on the Whitby, Redcar and Middlesbrough Union Railway. The railway station was opened on 3 December 1883 and was closed on 5 May 1958. The railway track has been removed and the station canopy is no longer in place, but the platforms still remain. The building is run as an activity centre by the East Cleveland Scout Group.

LYTHE

The word 'Lythe' actually means 'on a hill' and Lythe certainly is! St Oswald's church stands at the top of Lythe Bank and has fantastic views of the beach at Sandsend and towards Whitby beyond. There has been a church on this site since 1154 and there is a plaque inside the church listing every vicar from then to the present day. The church was rebuilt during 1910–11 and it was at this time that an amazing discovery of old carved stones was made. These stones were found while repairs were being made to some of the walls and buttresses, as the stones had been used in a previous repair. The stones have since been identified as being of Anglo–Danish origin, some of which are 'hogback' gravestones.

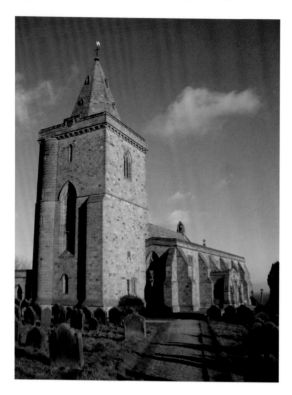

Left: **St Oswald's Church, Lythe**
The church stands at the top of Lythe
Bank with fantastic views of the bay
between Sandsend and Whitby.

Bottom: **Lythe Bank Vista**

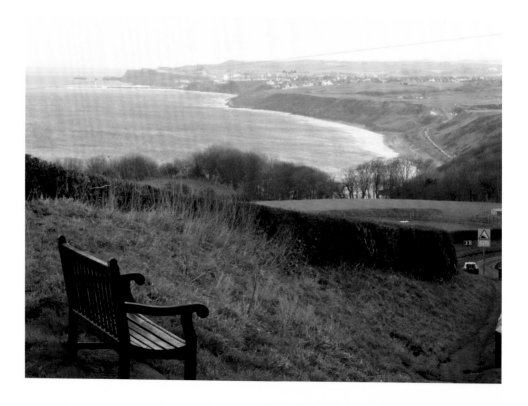

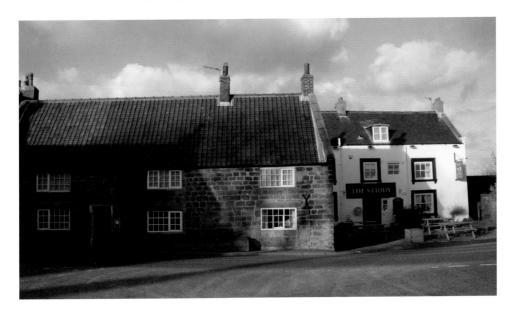

The Stiddy Public House, Lythe

The Vikings landed to the south of Lythe in 857 and laid waste to much of the surrounding area including Whitby Abbey. Some of the invaders settled in Sandsend where they opened a burial ground at the site of the church, which is where these stones came from. They date from the tenth and eleventh centuries, though there are also some post-Conquest Anglo-Norman ones and even small fragments dating from the eighth century, which could indicate that there was a stone church on this site prior to the Viking invasion. Thanks to public funding, a permanent display was officially opened by the Marquis of Normanby in 2008 featuring these stones alongside murals depicting life in the area during Anglo-Saxon times. Close to the entrance of the church is an ornate war memorial to the local men who lost their lives in the First World War.

MULGRAVE CASTLE AND GROUNDS

When descending Lythe Bank, the high fence on the right marks the boundary of Mulgrave Castle and woods owned by Constantine Phipps, 5th Marquess of Normanby. The woods can be accessed by the stone bridge in the centre of the village past the tea rooms. Mulgrave Woods are open on a permissive basis on Wednesdays, Saturdays and Sundays, with the exception of May. The remains of a Norman castle, built in the late eleventh century, can be found in the woods . The present castle is a castellated mansion passed to the Phipps family in 1718, when the Duchess's daughter Lady Catherine Annesley married William Phipps.

In 1858 Duleep Singh the last Maharajah of the Punjab, took a lease on Mulgrave Castle. In 2003, supermodel Elle MacPherson took out a lease on the 16,000-acre estate during the four-month shooting season. Occasionally the formal gardens are opened to the public and are well worth a visit.

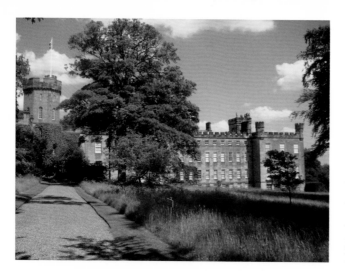

Mulgrave Castle
When descending Lythe Bank, the high fence on the right marks the boundary of Mulgrave Castle and Woods owned by Constantine Phipps, 5th Marquess of Normanby. © Jane Stokoe

SANDSEND

Two miles north of Whitby is the beautiful seaside village of Sandsend, it stretches along a fine sandy beach and is divided by a stream that feeds into the sea. The stream is crossed by a narrow stone-built Victorian bridge that only allows single file traffic, which can be problematic on busy summer days, as traffic lights are not used. The beach provides panoramic views of the historic Whitby Abbey, St Mary's church and the 199 Steps leading up to it. It is also very popular with fossil hunters, as Sandsend is part of what is known as 'The Dinosaur Coast' that runs from Staithes, in the north down, to Flamborough Head. In recent times Sandsend has become very popular with surfers due to the quality of the waves.

The railway line from Whitby to Middlesbrough passed through Sandsend and required two viaducts to be built; one at East Row, which is where the wooden cafe 'Sandside' stands today (it ran from here towards the village, judging by the old photographs I have seen; these must have looked spectacular), while the other was situated part-way down the Lythe Bank. Sadly the line, which opened in 1883 closed in 1958, the track was taken up and the two viaducts were demolished in 1960. The red brick railway station still stands, but is now a private house.

Sandside Café is owned by Neil and Karen Hodgson, who are brother and sister, they took over the business in 1994. *The Daily Telegraph* listed eight cafes 'Where best to grab a bite on the beach' which included Sandside – the only representatives of Yorkshire. They were also featured in *The Guardian's* list of 'The Yorkshire Coast's top 10 Eats'. Their website goes on to say,

So there you are, sipping a smooth cappuccino, your fork hovering over a rich home made cake, or a freshly made crab sandwich, the sun glinting off the sea. Oystercatchers patrolling the golden sands below, the North York Moors tumbling down behind and, away to your right the breathtaking two mile expanse of Whitby Bay all the way to the ruined cliff top abbey. Dream on? Well, no. This is the reality

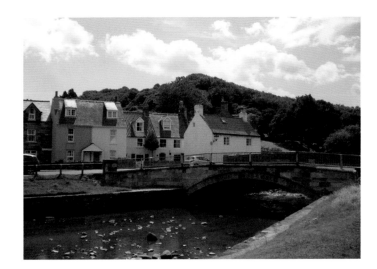

Sandsend Bridge
The bridge and part of the village street in Sandsend.

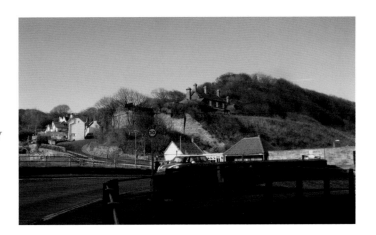

Sandsend via Lythe Bank
When first entering Sandsend via Lythe Bank look back up the bank; the red building in the centre of the picture is the old railway station (now a private house). The line would have continued to the left over the first high viaduct in the village.
© Jane Stokoe

of dining at the Sandside Café on North Yorkshire's stunning heritage coast. For more than a century visitors in search of refreshment, relaxation and hospitality have sought out the café-in-a-cabin which stands at the entrance to picturesque Sandsend village, an unspoilt gem of a place with old world cottages, towering sea cliffs, a secret ruined castle, woodland and a beach cut through by streams.

Leaving Sandsend towards Whitby there is Whitby Golf Course on the left that provides some of the best views of any golf club. The course looks along the coast, north-westward over the picturesque bay of Sandsend to Kettleness, south–eastward over the harbour with the Abbey Ruins clearly visible, and inland over the rolling countryside of the North Yorkshire Moors.

Opposite the golf course is Raithwaite Hall, once the home of William Headlam, the Whitby ship owner. Headlam bought the property and surrounding land in September 1940 after his office in Whitby had been bombed; he remained at Raithwaite until his death in 1991. The property is now a five star hotel.

Sandside Café
At the end of the village towards Whitby you will pass Sandside Café where excellent food and coffee is served. © Jane Stokoe

Sandsend Bay
A view from near Sandside Cafe looking around Sandsend Bay with an angry sea coming in.

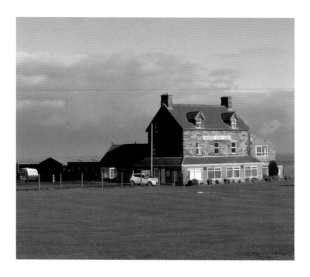

Whitby Golf Club
Along the coast between Sandsend and Whitby is the Whitby Golf Club with some of the best views any course has to offer

Acknowledgements

I would particularly like to thank my wife, Jane, for all her support in producing this book, we have had several enjoyable trips out in the car to improve on pictures I had taken some time ago and to carry out more research. My son, Ben, for helping me greatly with resolving a laptop problem which had stopped me transferring my pictures and text onto discs for my publishers and to my daughter Jessica for emailing lost text back to me from her computer which saved me retyping a large section of the book again! And my son Jonathon Stokoe at Stokoe Media.

Bibliography

The Arncliffe Arms, Glaisdale website: http://www.arncliffearms.com/

Birch Hall, Beck Hole website: http://www.beckhole.info/home.htm

Egton Bridge Gooseberry Show website: http://www.egtongooseberryshow.org.uk/

Lidster, J. Robin, *The Scarborough and Whitby Railway* (Nelson: Hendon Publishing, 1977)

Morris, P., *A visitors Guide to the North York Moors and Coast* (Beverley: Hutton Press, 1990)

Rhea, Nicholas, *Heartbeat – The Story Behind the Series* (Horncastle: Mortons Media Group, 2008)

Rhodes, Simon M., *Ravenscar – The Town that Never Was* (Smart Publications, 1997)

Stevenson, Myfanwy, *Sleights Eskdaleside cum Ugglebarnby 'Facts & Legends'* (Ryedale Printing, 1976)

Sandside Café, Sandsend website: http://www.sandsidecafe.co.uk/

St Mary's Church Goathland: websitehttp://www.goathlandstmary.com

Subterranea Britannica website http://www.subbrit.org.uk/ (regarding the RAF building at Goldsborough)

The Stables at Cross Butts website http://www.cross-butts.co.uk/

TV & Film Locations Guide - Northern England Edition (Page One Books)

Ventress, Monica P., *A Little About Littlebeck* (Scarborough: McRay Press, 2009)

About the Author

I was born in York in 1950 and started my first job when I was eighteen in Barclays Bank. I was made redundant by them at the end of 1999. At this time, I had spent just over thirty years working for the bank and wanted to try something different. This did not work out quite as planned, as I ended up working for the Scarborough Building Society, doing more of the same, for another five years!

In March 2004, my wife saw a job advertised by the North Yorkshire library service to operate and drive the Whitby mobile library. Needless to say I was interested!

For the next seven years I had the best job you could imagine: driving round the Whitby area in the mobile library. I had twelve rounds and did four each week. Sadly, this idyllic job came to an end in September 2011, when all nine mobile libraries in North Yorkshire were withdrawn due to government cutbacks. This book explores virtually all the villages I visited, but I have condensed them down to five routes.

I am now enjoying retirement greatly as I am able to spend more time with my wife, three children and six grandchildren. It also allows me more time to pursue my own interests, in particular, my love of Jowett cars. I do hope that you will find this enjoyable and informative.

Other Books by Noel Stokoe

Jowett, 1901–1954 (Archive Photographs: Images of Motoring), (Tempus, 1999)
My Car was a Jowett, (Tempus, 2003)
Jowett – Advertising the Marque, (Stroud: Tempus, 2005)
Sporting Jowetts, (Stroud: The History Press 2009)
Jowett – A Century of Memories, (Stroud: Amberley Publishing, 2010)
Jowett's of the 1920s, (Stroud: Amberley Publishing, 2013)